Architectural Photography

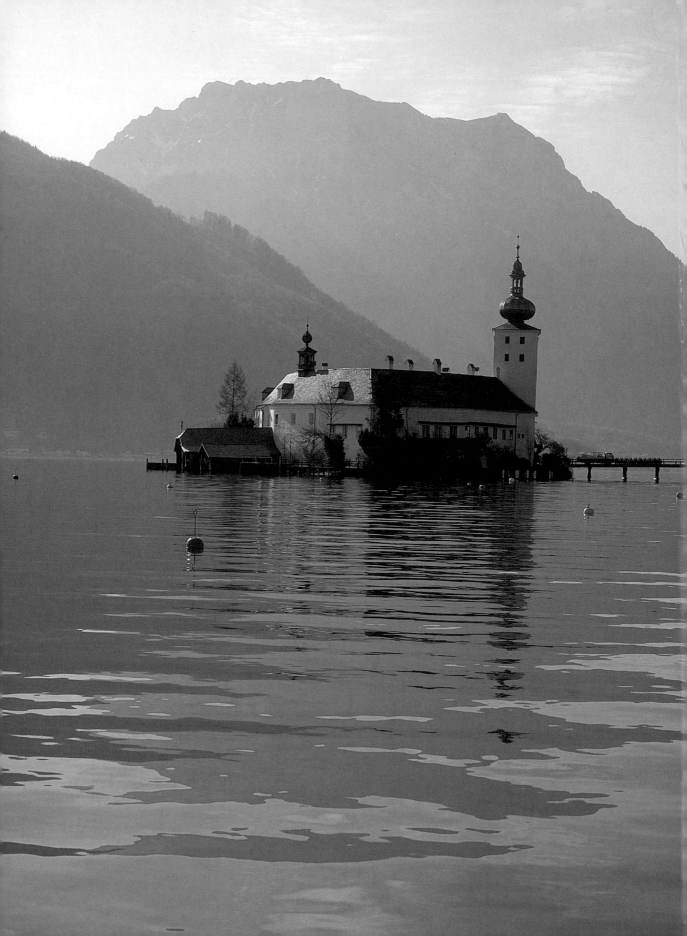

Architectural **Photography**

Jim Lowe

photographers'
pip
institute press

First published 2006 by
Photographers' Institute Press / PIP
an imprint of Guild of Master Craftsman Publications Ltd
Castle Place, 166 High Street,
Lewes, East Sussex BN7 1XU

ISBN-13: 978-1-86108-447-7
ISBN-10: 1-86108-447-1

Managing Editor: Gerrie Purcell
Production Manager: Hilary MacCallum
Photography Books Editor: James Beattie
Managing Art Editor: Gilda Pacitti
Designers: David O'Connor, Alison Walper

Set in Avant Garde and Univers
Colour origination by MRM Graphics
Printed and bound by Sino Publishing House Ltd, Hong Kong, China

'Good architecture is like a piece of beautifully composed music crystallized in space that elevates our spirits beyond the limitation of time' Tao Ho (b.1936)

'In architecture the pride of man, his triumph over gravitation, his will to power, assumes a visible form. Architecture is a sort of oratory of power by means of forms' Friedrich Nietzsche (1844–1900)

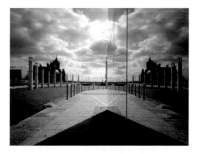

Acknowledgements

I would like to thank the friends who helped me compile this book, these include: Roy Sims FBIPP, Bob Lawrence LBIPP, Llewellyn Robins FBIPP, Tony Freeman LBIPP and Nadir Chanyshev from the Russian Photographic Federation who was my guide and translator in Moscow. A special mention has to go to Jon Hicks FBIPP, a great travel photographer, for allowing me to use some of his images. Useful reference material came from the *British Journal of Photography* based in London (www.bjp-online.com). I would like to thank my wife Sue for her patience and endless cups of coffee and my daughter Sharon for her support.

Contents

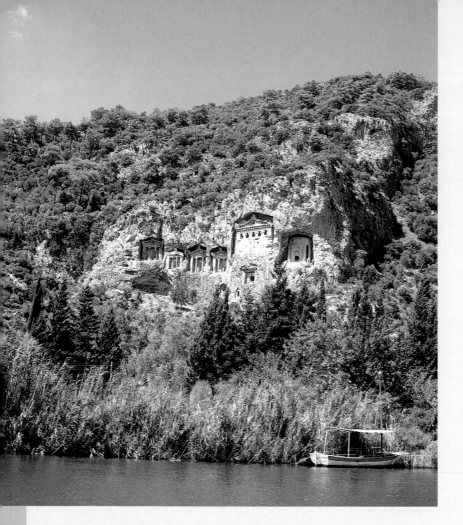

Architectural photography takes many forms, whether this is capturing a portfolio of shots for a professional client or simply taking holiday photos of ancient sights like these tombs in Fethye, Turkey. While there is a great deal of variety within architectural photography there is also much that unites it, and the skills that are laid out throughout this book will give you the foundation to cope with all of these different challenges.

Mamiya RZ67, 1/125sec at f/16, ISO 100

Introduction

Architectural photography is the art and science of capturing images of buildings, inside or out. The technical side lays the foundations of a good image, while the art aspect, which is a key element involving shape, composition, colour and design, characterizes each photographer and is what sets us apart from one another. How we see a building, how we think it should be photographed, which equipment to use, the composition and even the time of day are all creative challenges to which different photographers will find different solutions. This capacity for creativity – the fact that a variety of photographers photographing a single building will each come back with a different set of images – is the joy of architectural photography.

The science of capturing architectural photographs is down to the technicalities of manipulating the camera, determining the exposure, measuring the colour temperature and capturing the image, as well as any post-production that is required. There are some excellent technical photographers who can produce perfectly sharp and well-exposed photographs but whose work lacks any creativity and imagination. Technical expertise can be learnt by rote but style and imagination is individual to each photographer, and is what sets the good ones above the rest.

Architectural photography at its best represents something attractive to the viewer and hopefully makes them more aware of the buildings surrounding them. In architectural photography, the artistry needs to be imaginative, but it should be backed by technical knowledge, as while creativity is largely a personal affair it can be difficult to achieve without a good basic technique. In this book I have tried to encompass the many aspects of architectural photography by incorporating techniques that will come in useful when photographing buildings inside and out. Alongside basic technique I've included many tips and tricks that I've picked up along the way and recorded for future use should I come upon them again.

Buildings are a fascinating assertion of humans upon their environment and photographers' images of architecture are as relevant today as they were when William Henry Fox Talbot photographed the lattice window in Laycock Abbey in 1835 using the first one-inch square paper negative. Even the world's very first photograph taken by the Frenchman Joseph Nicéphore Niépce in 1826, with an exposure of eight hours, was the view from his room showing buildings in his home town. So, the earliest images to be captured permanently on film by a camera were architectural, mainly owing to the fact that buildings were the only subjects to keep still long enough for the necessary exposure times!

From that time to the present architectural photography has been used to look backward at history and tradition in order to move forward. Architects generally prefer to be seen as progressive and enhancing the environment with the buildings they design. Every country in the world boasts its own cultural approach to architectural design, both traditional and modern, and it would be interesting to discover when humankind decided it no longer wanted its buildings to be solely utilitarian, but to also be attractive statements of purpose and design. The stone circles in Europe, such as Stonehenge in Britain, the Pyramids of Egypt and the tombs carved into the rocks at Petra in Jordan and Fethiye in Turkey are all examples of great structures whose grandeur soars above and beyond their initial functions.

Illustrators closely followed this creativity and spread the word of such masterpieces throughout the known world. The Greek and Roman empires spread their culture and distinctive architecture as symbols of power and military might. Even today the modern world embraces historical architectural designs as iconic representations of power, classic examples being the Capitol Hill and White House buildings in Washington and the Arc de Triomphe in Paris. Typically, the French Revolution produced a generation of designers and architects for whom the classical design interspersed with ornamental elements from the Middle Ages was the trigger for some amazing structures. Ledoux and Boullée were at the forefront of new ideas and Boullée stated that: 'I am too a painter' demanding a painter's licence for his architectural designs. He wrapped his designs and illustrations in awesome light and shade, and they in turn became collectors' pieces. Visual design for architecture always has been one part of a designer's intentions giving as much intellectual satisfaction as visual pleasure.

Between 1760 and 1800, the appreciation of architecture as a visual art manifested itself in what was called the 'picturesque' being

transferred from landscapes to architecture. Rich men commissioned Gothic castles, Greek town houses, Tuscan villas, and architects such as John Nash, who designed the curved Regent Street in London, made use of strong visual shapes in their designs. Consequently, artists and illustrators were inspired by such architecture in their paintings and drawings. The same is true of architecture today, with examples of stunning forms such as the Sydney Opera House, the Taj Mahal and the Chrysler Building in New York becoming magnets for painters, illustrators, photographers and film and television makers. The resulting images are seen throughout the world and have become so familiar to the public that viewers often feel they know every architectural detail of such famous edifices as if they were just next door. The vast majority of the world's population will never actually see these buildings *in situ*, but we can all recognize and appreciate them through the visual media, especially television and in this case photography.

Throughout the ages architects have evolved a great variety of building styles and concepts reflecting their political and social eras. On the whole we love our buildings, whether in small towns, villages or in big cities, and as a species we live, work and occupy most of our leisure time using these structures, which range from the purely functional to the boldly artistic.

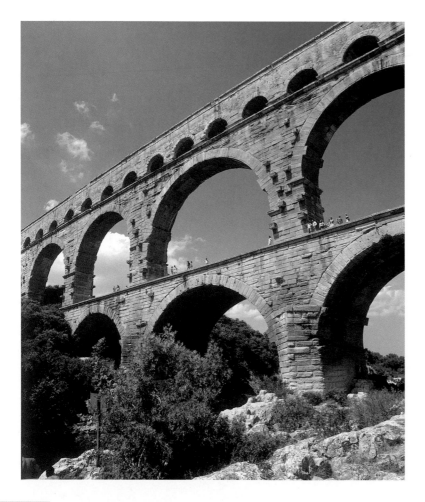

◀ **The Pont du Gard in Nîmes, France, was built by the Romans just before the Christian era in about 50AD. It was constructed to allow water from the Eure Spring to flow via an aqueduct to Nîmes and to cross the River Gard. The bridge stands almost 50m (160ft) high and is built in three levels of arches. While the purpose of the viaduct is ostensibly functional its undeniable beauty underlines the attraction of taking photographs of structures that combine form and function.**

 Mamiya RZ67, 1/125sec at f/11, ISO 100

▶ **Stonehenge in Wiltshire, UK, is an ancient site and a great example of the way in which early constructions began to be designed not just to meet a functional purpose, but also with the importance of aesthetics in mind.**

 Mamiya RZ67, 1/60sec at f/8, ISO 100

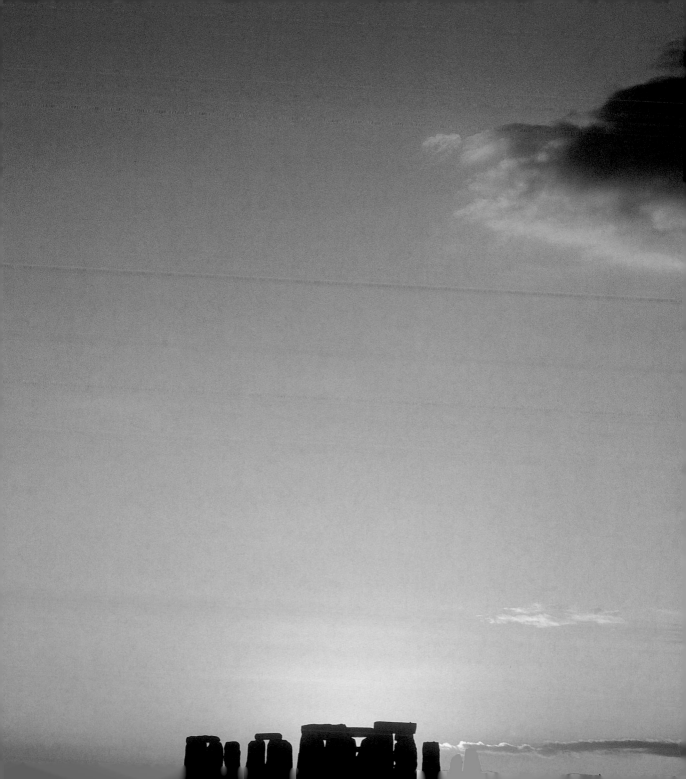

Architectural photography emerged as a recognized visual medium in the 1860s, as the necessary long exposures made buildings an ideal subject for the early photographers. The architectural photographers of the late Victorian and Edwardian era shot contemporary buildings on 12x10in glass plates using small apertures and filling the frame. The resulting stark images were readily accepted by architects as a true-to-life portable portfolio of their finished work, but the images lacked any life of their own as they were unreal and narrow in perception, in fact the sharper and more detailed, arguably the less creative, the photograph the better the architect liked it.

Construction methods are constantly changing, and yet we can still appreciate the beauty, charm and graceful lines of architecture going back hundreds of years as well as that of the modern era. From about 1890 onwards architects began to work alongside engineers to revolutionize their structures and this was pioneered in America with the first skyscrapers, which appeared in Chicago and New York. The American architect Louis Sullivan stated that in his designs form should follow function, and freed

▼ **Cribbs Causeway shopping mall in Bristol, UK, is a great example of how contemporary architecture has evolved through the use of modern materials, lighting and landscaping.**

◉ Sinar X, 8secs at f/16, ISO 100

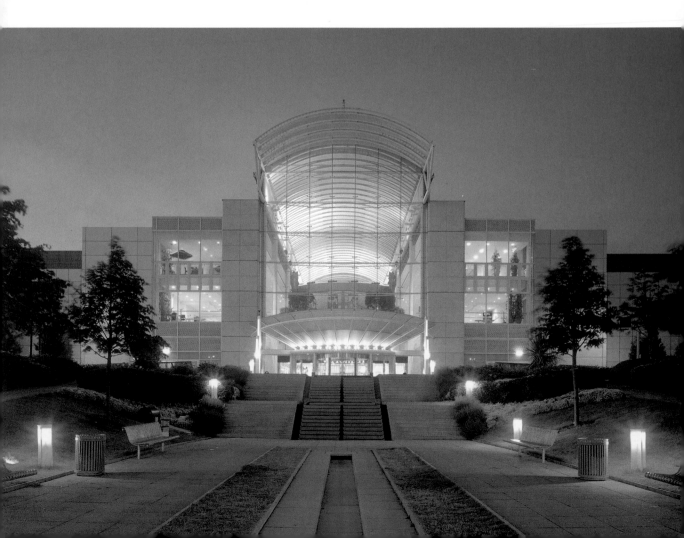

Case notes 1

Sometimes architectural photography can take you to places you would never normally experience, such as this pool in an exclusive health spa in Cirencester, Gloucestershire, UK. It was modelled on an ancient Roman bathhouse, which had been built in the town by the Roman occupiers approximately 2,000 years ago.

The lighting consisted of many tungsten down lighters recessed into the ceiling and alcoves, and posed particular challenges, but by coupling careful technique using colour-temperature meter with a considered composition I overcame the difficulties faced and produced a pleasing image.

📷 Sinar X, 12secs at f/16, ISO 64

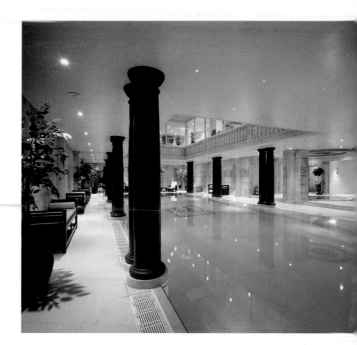

from historical styles of the past modern buildings needed to reflect contemporary needs and intentions, hence the emergence of one of the first skyscrapers, the Guaranty Building in Buffalo, New York. Another well-known American architect, Frank Lloyd Wright emerged as the father of modern architecture stating, 'I want my buildings to be enjoyed by the many and not the few.' It was during this renaissance of architecture and the use of the still relatively new medium of photography that the public began to see both architectural designs and photographs as art in their own right. The specialist architectural photographer was born.

During the years between the two World Wars architectural photography became more creative as photographers experimented with new techniques and ideas; their use of strong shadows and diagonal lines gave their images a dramatic style. As a result of this architects commissioned more photography, especially in the 1950s and 1960s, promoting architectural

photography as an art form. Since then the advent of faster films, smaller cameras and digital technology has resulted in an almost photo-essay style of architectural photography, which shows a realistic view of the impact of architecture on everyday lives.

To quote Le Corbusier, 'the building is a machine to either work or live in'. However, buildings can still evoke strong passions and have held unparalleled influence for untold generations, through both conflict and peace. Some photographers have learnt to give character to buildings by dramatizing their functions; to a photographer, buildings offer endless opportunities to capture the statements expressed by architects.

It is important to have a good knowledge of the technicalities of image capture before launching into architectural photography. This is where the photographer's understanding of light and shade, textures, symmetry and composition, lend themselves specifically to architectural photography.

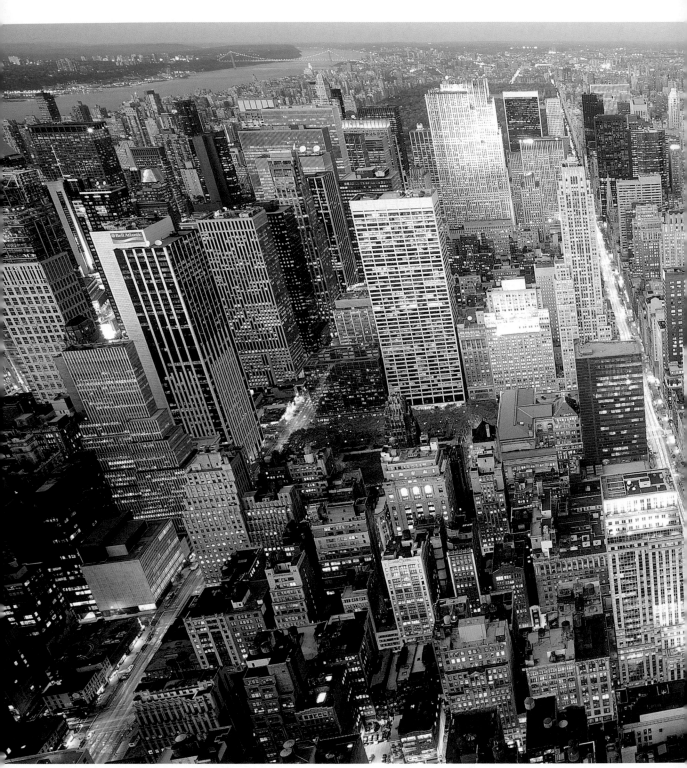

© Jon Hicks, FBIPP, email:jonhicks@cheerful.com

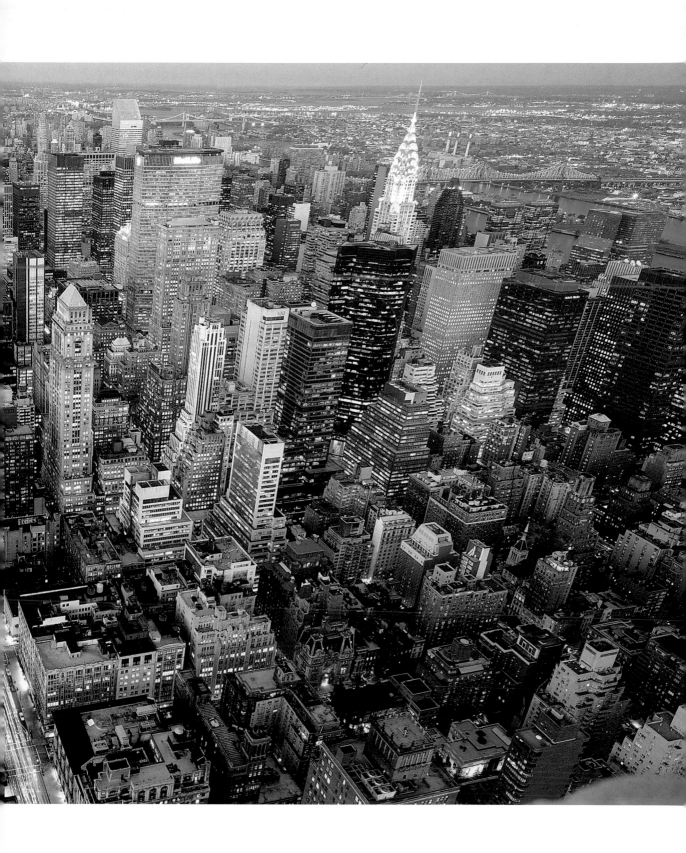

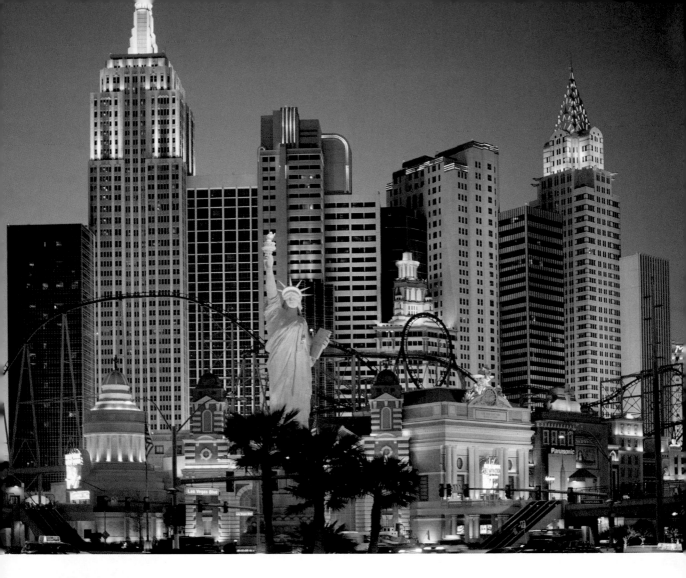

Shot by travel photographer Jon Hicks this aerial shot of the New York skyline is just the kind of image that would look good as a fine-art image blown up large and displayed on a wall.

📷 Details not recorded

The process of taking a photograph is so easy a child can do it; autofocus, autoexposure and no film to process make it easy to take photographs with small, modern digital cameras. Images are even captured using cameras installed in mobile phones, but understanding the basics of architecture and having the skill and vision to see the final image is what separates a photographer from the casual snapper.

Photographing architecture can be challenging and while the majority of pictures are usually used as sales aids or for recording purposes, there is no reason why people should not receive pleasure from seeing the images as works of art in their own right. Conceiving the image is only one facet of visual perception, but it is this that allows the photograph to be seen as a strong visual or graphic statement.

Galleries offer a wide range of posters and prints of historic and attractive buildings, such as the Empire State building, The Guggenheim Museum in Bilbao or even a variety of styles

◀ **The Las Vegas skyline is extremely crowded, and although not to everybody's taste certainly makes for a spectacular image, especially at night.**

📷 Mamiya RZ67, 1sec at f/8, ISO 160

typified by the Las Vegas skyline. The demand for these images is immense; everywhere you go you see evidence in books, magazines, travel brochures, calendars and posters. There are many books, articles in journals and magazines on architectural photography by some excellent photographers emphasizing architecture's visual strength, design and conceptual quality, without which there would be no challenges for the photographer to attempt to capture in the first place.

Architectural photography can be one of the most satisfying photographic disciplines, but by definition it follows a more structured path than most other types of photography. This does not mean it cannot be fun and creative; as a professional the majority of the assignments I undertake include a few creative photographs for use on a brochure front cover, website, or magazine, while amateurs need not be restricted by commercial considerations and can please themselves when it comes to thinking creatively.

A professional architectural photographer should have a natural empathy with their client, an understanding of the inspiration that resulted in their designs in the first place. The main aim of most photographs is to capture the essence of the building, the clarity of design, be it exteriors or interiors, or, to quote one architect who commissions me, to 'capture the soul of the building'. This is also a good guideline for amateur photographers as well, who should aim to capture what it is that makes that building unique. However, budding professionals will still be expected to illustrate all aspects of the building, including relatively mundane ones, alongside the more creative and abstract images.

Any photographer, amateur or professional, who undertakes architectural photography should have at least some understanding and appreciation of buildings, their environments and their diverse functions. Otherwise the pictures will become just 'product' shots and anyone who is competent with a camera could take the same images. The sheer variety of buildings and construction styles should create a fertile collaboration between the photographer and architect, offering many challenges to inspire and stimulate the viewers of the final images. However, without being interested or excited by buildings even a good technical photographer will find it difficult to achieve impressive results.

Architectural photography has certain similarities to other types of photography; however, it can be very different in approach and execution, as it requires a lot of patience, an understanding of atmosphere, space, light and perspective. The images you produce should show your interpretation of the subject and convey your signature style. Everybody's photography has a creative edge, those special qualities that mark the differences between each of us: how we develop our selective vision; does the composition feel right; how does the image communicate the photographer's perception of the scene in front of the lens? This does not mean that other disciplines do not have the same criteria, but architectural photography requires a strong understanding of these elements if an image is to be successful.

This field of photography is demanding and often methodical, but at the end of the day, once all the challenges have been overcome, it can be immensely rewarding and fun. One

piece of advice, as shown by the images in this book, is to keep it simple and try not to overcomplicate the process. It's easy to be seduced into using too many lights, filters and intricate techniques to achieve your results. However, on most occasions a good understanding of the basics coupled to a creative eye and a passion for architecture can prove far more valuable and make for some great photographs.

◀ ▶ Perhaps the most enjoyable aspect of architectural photography comes when you are able to move beyond the more prosaic images to impose a creative feel on your images. Learning to think creatively is something that will come with experience; however, it should be based on a firm foundation of technical knowledge.

 Left: Sinar X, 4secs at f/22, ISO 100
Right: Sinar X, 1/30sec at f/22, ISO 100

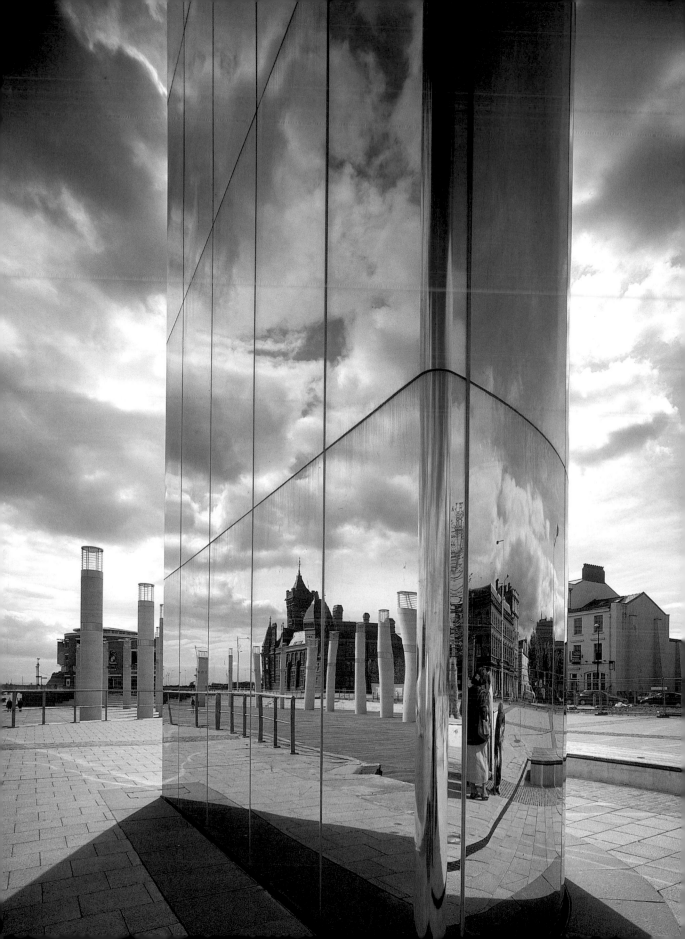

Tools and Materials

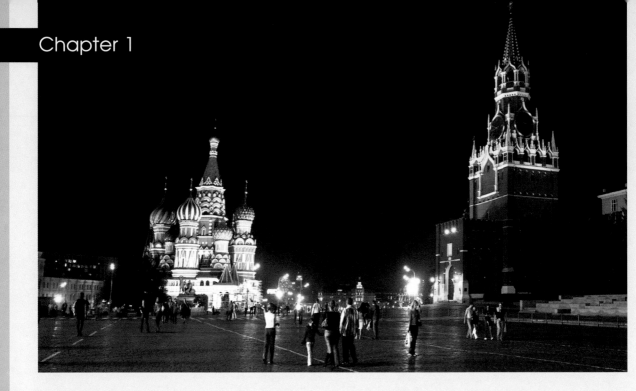

Cameras and systems

The choice of the camera that you use to photograph buildings' exteriors and interiors depends on your personal requirements. The decision to use film or digital, how much you wish to spend and how the camera performs in everyday use are going to be the key questions when making that all-important purchase. Like all things in life you get what you pay for and cameras used for architectural work are no exception. There are a wide range of camera types available, from a variety of different manufacturers and each is suitable for a different set of applications. Choosing the right camera system is about balancing those different demands.

Despite the advance of technology there is still a place for more traditional cameras and it is reassuring that they are still available as large- and medium-format cameras. As an architectural photographer I like the concentration you need to use a large-format camera, though it does take away some spontaneity. I also use a medium-format camera to expose more images in a shorter period of time, while I have a digital SLR that is useful for detail shots and for sheer convenience. At the end of the day it comes down to personal choice, and this chapter gives you the low-down on each system.

The night shot taken in Red Square, Moscow, Russia without a tripod was hand held, with the camera ISO set on 800 and by resting the camera on something solid. The flexibility of digital capture has moved photography forward a great deal, however, there is still a large role for film to play.

 EOS 1Ds, 1/30sec at f/8, ISO 800

Caring for your camera

Whatever your camera system, during years of use it can be subjected to extremes of temperature, humidity and physical hardship. Admittedly these conditions do not occur very often, especially if you specialize in interior photography, but it is useful to take a back-up camera on location whenever possible. However, prevention is better than cure and I wrap my cameras and lenses in plastic bags and line their cases with bubble wrap; there are also many specialist bags and cases available. Be sure to choose one that is comfortable to carry, as a heavy camera load can cause back problems if not distributed comfortably.

Some buildings can vary in temperature from one room to another, for instance swimming pools can be very warm and humid causing the lens and camera to steam up once you have entered the room. Other buildings often have dusty environments that can have an adverse effect on your camera's performance, particularly any batteries or delicate electronic circuits, so you should take every care to keep your camera clean and dry. Simple cleaning kits can be bought relatively cheaply and you can also use a UV filter to protect your lenses.

Digital cameras

Digital cameras are not as different in practical terms from their film predecessors as you might think, but the main divergence is that digital cameras capture the image using sensors in place of film. The light-sensitive diodes, which make up a grid on the sensor, transform the light reaching them into pixels. The information is processed in the camera and passed to a memory card for storage. This information can then be downloaded so that a computer, with the correct software program, can construct the final image, which can then be printed out as a hard copy and also stored on disk.

By using a digital camera a photographer saves on film and processing costs, which can be quite considerable over a period of time. However, the initial cost of digital equipment is higher than that of its film equivalent, and you should take into account not only the cost of not just the camera, but also the associated accessories such as memory cards, computer upgrades, software and so on.

Aside from the differences between film and sensor, digital cameras have many of the functions of traditional film-based ones. The quality of many digital cameras matches or surpasses the quality that could be provided by film, and a digital camera with a resolution of around six megapixels is considered to offer detail equivalent to that of a professionally scanned 35mm transparency. However, the resolution varies from one camera to the next, and you should consider just how large you will be displaying your images.

While resolution is a major consideration when purchasing a digital camera it should not be your only one. There are many other factors, one of the most important being the physical size

of the sensor. Most digital compacts and digital SLRs have cropped sensors that are smaller than a 35mm film frame. There are a number of different sizes available, and their quality varies accordingly. However, because smaller sensors normally mean smaller pixels a small sensor can make for a lower-quality image. This is a good case against buying a digital compact compared to the bulkier, but typically higher-quality digital SLR cameras.

The size of the sensor also has two other important effects that you should bear in mind. These are on depth of field, which is discussed on page 69, and on the effective focal length. A sensor that is smaller than a 35mm frame has an effect similar to that of multiplying the focal length of the lens in use. Because of their size cropped sensors mean that a lens will have a narrower effective angle of view when used with a cropped-sensor digital SLR than when used with a 35mm-film or full-frame SLR, this is

obviously an advantage if you use telephoto lenses a lot as it exaggerates their effect, but is diminishes the effect of wideangle lenses. While telephoto lenses can be useful, particularly for picking out architectural details, wideangle lenses are more frequently used so it is worth looking at digital cameras that either have full-frame sensors that are equivalent to a 35mm frame, or, as these can prove expensive, a range that includes a digital-specific wideangle lens.

In terms of quality and functionality there are also a number of other factors that you should consider. A camera that offers good quality at high ISO ratings (see page 69) will prove invaluable when confronted with low light conditions such as the domes in churches shown here. Fast burst rates (the number of frames per second) are generally not so important, but the option to shoot in a raw format (which many compact cameras do

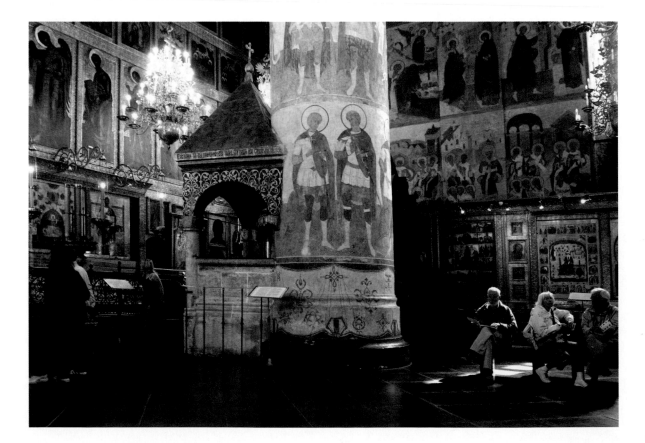

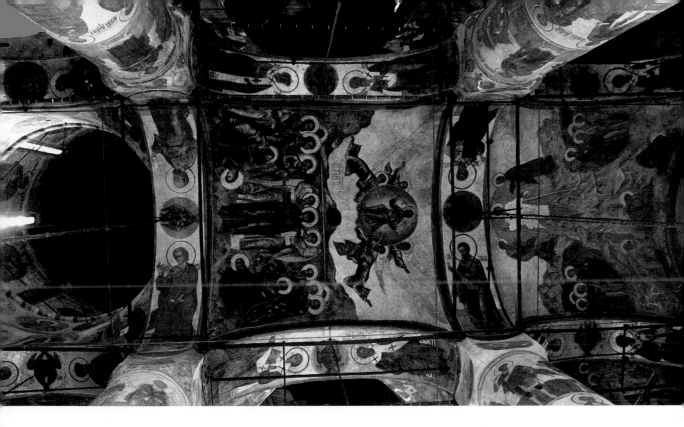

These images of the interior of the Archangel's Cathedral in the Kremlin, Moscow, Russia, are taken with a 17mm wideangle lens on a digital camera and work well as the lens distorts the natural perspective of the interior and uses the converging verticals as a key element in the composition. These pictures, taken without using a tripod, were only possible because of the camera's flexibility and ease of manipulation to light sensitivity. In these situations you also have the luxury of checking the results almost immediately and re-shooting if necessary.

📷 EOS 1Ds, 1/40sec at f/4.5, ISO 1600

not offer, but digital SLRs do) can be very useful. Obviously a good-sized screen on the back of the camera can be invaluable when it comes to viewing your images in the field, and again digital SLRs tend to offer larger ones.

For professional-quality architectural photography it is best to use the high-quality cameras that offer a wide range of features and produce high-resolution images. However, if you are simply indulging a hobby then you should take a look at cheaper models that may provide you with better value for money. If your budget can stretch to it I would recommend using a digital SLR as opposed to a digital compact for two reasons: firstly, that the quality is generally higher; secondly, that the versatility afforded by the range of lenses and other accessories that support them is far greater. However, if you already have a compact camera, or you wish to invest in one because it is the best all-round option for your photography you will still find that most of the advice that is contained within this book will still apply.

If you do purchase a basic digital compact you should check that you like the colour response, contrast and sharpness that it offers, as unlike with digital SLRs you may not be able to make alterations in-camera.

It is worth remembering that if you purchase a high-end digital camera the back-up equipment such as lenses, monitor and printer will all have to be of comparable quality or the results will disappoint in relation to the expense of the camera.

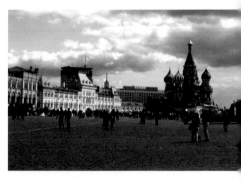

◀ ▲ The Kremlin compound and Red Square in Moscow, Russia, are home to a number of churches that house incredible decorations that are characteristic of Russian Orthodox Christianity. A digital camera is a great tool for such situations that demand portability and flexibility.

📷 Above: EOS 1Ds, 1/125sec at f/16, ISO 100
Left: EOS 1Ds, 1/100sec at f/20, ISO 100

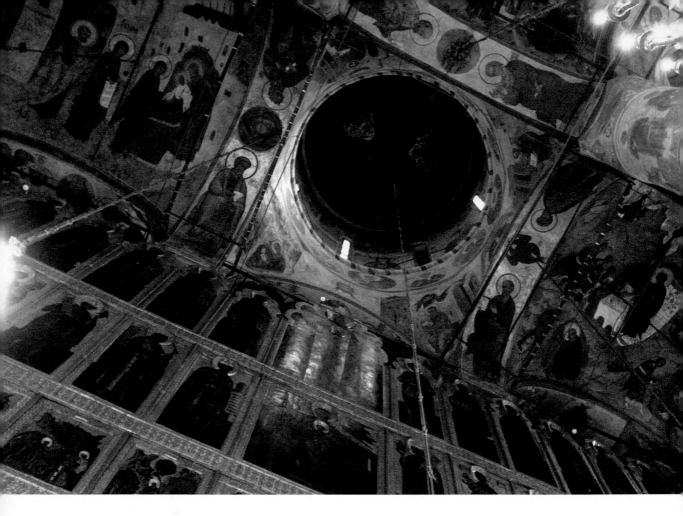

▲ This shot of the Assumption Cathedral, Moscow, Russia was taken without using a tripod or flash. This would have been almost impossible using a film camera without a tripod. The fact that you can check your images almost immediately before moving on into the next room is one of the major advantages of digital cameras. I still prefer the quality of my large-format film images, but I would never have been able to capture the image as easily as I did without a digital camera.

📷 EOS 1Ds, 1/30sec at f/5.6, ISO 1600

▼ A digitally spliced panorama (see page 30) of a series of black & white photographs taken on a medium-format camera with a 110mm lens. I panned the camera on a tripod until I had covered a full circle, allowing an overlap of approximately one third of each frame on either side. This made it easier to marry each element accurately within the picture, once the transparencies had been scanned to computer, without any distortion occurring.

📷 Sinar X, exposure not recorded, scanned and stitched in Photoshop

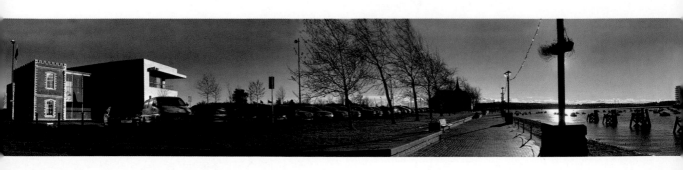

Electronic imaging

The advent of digital technology has changed the industry massively and made photography more open to people who want to try their hand at it, but who have been put off by the technical aspects of traditional cameras and film. However, the basics of architectural photography such as planning, logistics and of course the element of composition are still relevant regardless of the medium you use to capture the image.

One of the main advantages of using a digital camera is the ability to see your images almost immediately, and to correct any faults and take the image again. However, if there are certain problems that you can't solve in-camera or there are manipulations that your image requires for creative or technical reasons the potential for manipulating your images on computer is enormous.

There are three main file types that are widely used in digital photography. A group of proprietary file formats known as raw files, the universal uncompressed tiff format and the universal compressed jpeg format.

The most common image format is jpeg. This is available on all digital cameras and is universally readable. Jpegs are compressed files, and the amount of compression can be varied. This means many more images can be stored on a memory card or hard disk and that they can be easily emailed; however, compressing jpegs does have its drawbacks as picture quality deteriorates as compression

increases, with heavily compressed files being compromised in areas of continuous tone. So, if you are shooting jpegs stick to the higher-quality settings unless you are really short on space. One thing to bear in mind when shooting jpegs is that the image variables such as white balance, sharpness, contrast, saturation and hue cannot be changed later on computer, so you need to make sure that you get them right in camera.

Unlike a jpeg, a raw file is basically an unprocessed image, which needs to be converted using the software supplied with your camera or third-party software such as Photoshop CS, Breeze Browser or Raw Shooter. Shooting in raw allows you to tweak the

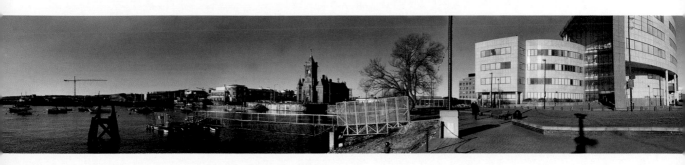

exposure, control the white balance and manipulate sharpness and various colour settings on computer. The downside of a raw file is that it really does need some work, otherwise it will tend to look slightly flatter, duller and less sharp than the equivalent jpeg would.

Tiff files are also worth mentioning as, although most cameras do not offer the option of shooting in tiff format, many people choose to convert their images to this format on computer. Unlike jpegs they are normally not compressed so they produce larger files; however, this means that they do not lose information and they are also useful because they can be universally read.

Exposure with digital cameras has to be carefully controlled as many of them don't handle highlights very well; these can 'burn out' if the exposure is made just for the shadow detail. However, by using negative exposure compensation (see page 72) you can first underexpose the image then lighten it using software at the same time as retaining highlight detail.

While many architectural photographers still use film, even they scan their transparencies or negatives to take advantage of computers and software for manipulating, transmitting and archiving their images. This allows all sorts of corrections to be made such as removing unwanted distractions, eliminating colour casts or correcting converging and diverging verticals.

Another great digital trick is taking a series of overlapping images and splicing them together using software such as Photo-stitch or Photoshop to create panoramas. This can be particularly effective, and you can even go as far as creating 360° landscapes. Using a sturdy tripod with a spirit level and a lens that isn't so wideangled that it gives barrel distortion at the edges, you should take a series of images with an overlap of approximately 30 per cent, keeping your exposures constant as you pan the camera. You can then set your software to work stitching the images as you desire.

The long-term future is undeniably electronic but traditional film equipment will be a feature in photography for years to come. On a personal note, the agencies that commission me, usually prefer large- or medium-format transparencies because of the quality. It gives them the freedom to manipulate the scanned images on their computers and design the literature using the images as the template. Once the job has been completed they either store the original transparencies as a master set or pass them onto their clients. The tools are changing but the control and flair of the photographer, whatever method is used to take the photograph, is the factor that will determine the appeal of good architectural images.

TOOLS OF THE TRADE

Digital flexibility

Although I primarily use a large-format camera I also complement it by using a digital SLR for some of my work. These cameras are ideal for recording architectural details and for aerial photography. I normally set my digital camera to expose at ISO 100 for the best quality but with a press of a button I can upgrade the sensitivity to ISO 1600 or 3200. This flexibility is one of the key advantages of a digital camera in comparison with a film camera.

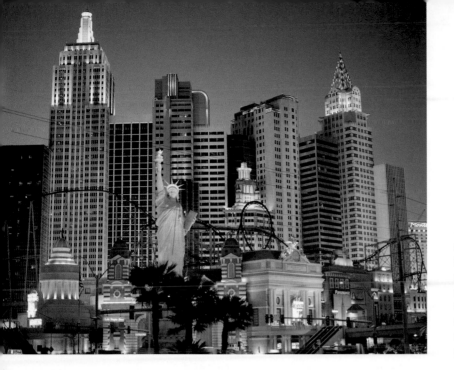

◄ ▼ The major advantage of electronic imaging, whether the image is captured digitally or on film and scanned, is that you have the opportunity to perfect your image on computer. This shot of the Las Vegas skyline has had its converging verticals corrected and some distracting powerlines removed.

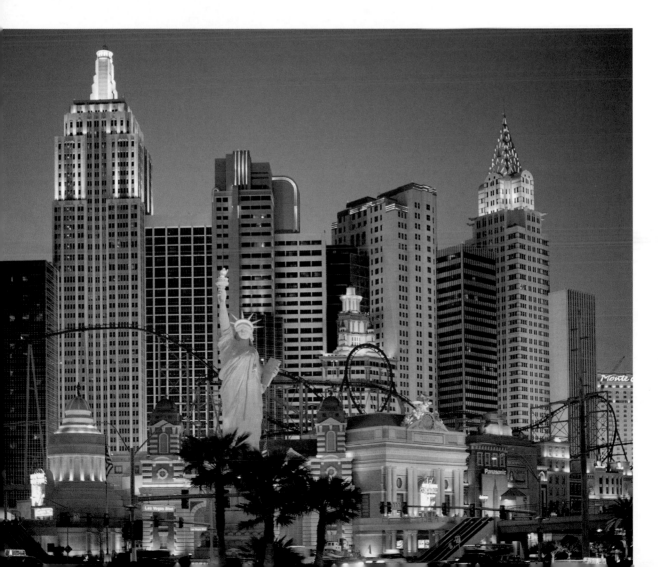

Film cameras

Although digital cameras are very much the shape of things to come that doesn't mean that you should disregard film cameras altogether. There are some real bargains to be had as the wealth of new digital options has pushed the price of film-based models down. This means that you can pick up what are relatively high-specification film cameras, perhaps even a medium- or large-format camera, for the price of a consumer digital SLR. However, you should be aware that while the initial layout may be lower, buying and developing film will mean that the running costs are higher.

35mm SLRs

It is very rare for an architect to commission a photographer for an architectural assignment and request the 35mm format as it is too small to give the high-quality images expected by architects. However, for an amateur these cameras do have their uses, particularly if you are combining your architectural photography with other subjects. 35mm SLRs are easy to use, flexible and relatively cheap. Like digital-SLR systems, there are a stunning array of lenses and other accessories available; most of which, although not all, can be used on both digital and film SLRs. These cameras make it possible to change lenses quickly and compose and shoot frames in quick succession giving you more versatility than a medium- or large-format camera.

Some excellent lenses are available, including tilt-and-shift lenses that replicate some of the movements of a large-format camera and are manufactured primarily for architectural photography. The wide range of relatively affordable focal lengths opens up a host of creative options. However, 35mm SLRs have been superseded by their digital counterparts, which have most of the advantages, but without any material costs.

Medium-format cameras

Film medium-format cameras accept rollfilm, and still retain a great deal of the versatility of the smaller 35mm-format cameras, while offering a larger frame and therefore greater resolution. Despite digital advances a scanned medium-format transparency will hold more resolution than a digital SLR, and digital medium-format cameras are prohibitively expensive. This makes film medium-format cameras a good option if you want to display the final image very large.

Medium-format cameras do not have the same array of lenses at their disposal that smaller digital and film SLRs have. However, they do offer a wider variety of focal lengths than are available for large-format cameras. Different cameras provide different frame formats (despite using the same size of film), 6x4.5cm, 6x6cm and 6x7cm are the most common. So there is plenty to choose from depending on which is your preferred format, or which type of subject you intend to shoot.

Their ease of handling, at least compared to large-format cameras, makes medium-format cameras ideal for detail shots and moving subjects, such as people in large interior spaces, and crowded pavements where larger cameras would be too cumbersome and unwieldy, however, the lack of movements – as is the case for smaller-format cameras – restricts their use for professional architectural work, although any converging verticals can be corrected if scanned, it is better to avoid them in the field. Medium-format cameras are quick and simple to use, and therefore best suited to illustrating details of construction, design and creating dynamic abstract images with which to complement a series of more prosaic photographs. They also come in useful in situations where a large-format

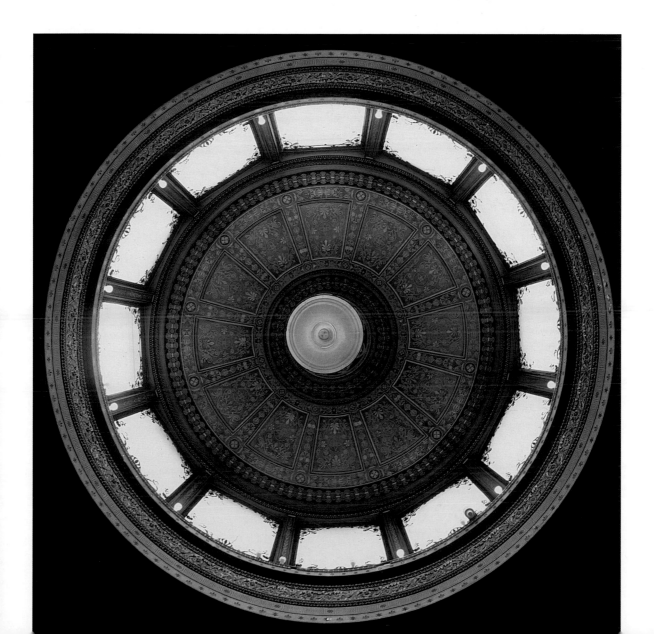

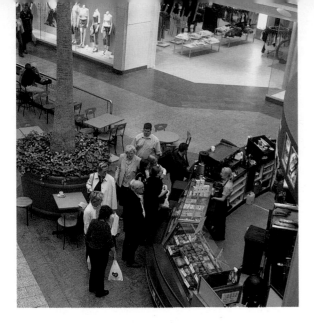

camera would be totally impractical, such as when capturing views from the highest points on a building, which can only be reached by climbing endless flights of steps.

The medium-format camera is well suited to this sort of architectural work, allowing the photographer to easily move the camera around at the same time as looking through the viewfinder until the image is just right. However, even with these cameras it is advisable to use a firm tripod whenever you are able to.

Most architects like to see people using the buildings in any photographs, after all their structures are designed with people in mind. The versatility of handheld cameras makes them a suitable option for this sort of photography, allowing the photographer to be less obvious and intrusive, while the medium-format camera allows you to maintain a high enough quality file for professional, or high-enlargement usage.

Another useful feature of medium-format cameras is that the majority of them afford you the option of shooting on instant-print film such

⊕ TRADE SECRETS

Aerial photography

Handheld medium-format, 35mm and digital SLR cameras are ideal for taking aerial photographs. Getting airborne is one of the best ways of surpassing the problems of shooting in confined areas such as cities, or adding a more creative element to your portfolio; however, while it might be a viable option for pros, for amateurs it may be limited to a once-in-a-lifetime opportunity. A fast shutter speed, 1/400sec and above, is

essential to prevent camera shake from the vibrations from the aircraft. From personal experience I have found that helicopters are the best camera platforms but they can be expensive to hire in comparison with aeroplanes. The ability to ask the pilot to hold a position over the subject long enough for you to make as many exposures as possible is a real help.

as Polaroid; this is the film version of the playback monitor on digital cameras and, while less convenient, it does at least allow you to check exposure in the field. Unfortunately not all makes of camera systems have the attachments necessary to accommodate instant-print film, however the majority do.

Overall, a medium-format film system offers you a halfway point between the flexibility of small-format cameras such as film and digital SLRs and the quality offered by the size of an image from a large-format camera. They can also represent surprisingly good value for money as the prices commanded by second-hand cameras are depressed by the large number of photographers trading in their professional-specification film cameras in order to switch to digital capture.

Large-format cameras

Large-format cameras, otherwise known as view cameras, use sheet film, rather than rollfilm. Like medium-format cameras, there are a number of different models offering different image formats; however, the most popular for architectural photography is the 5x4in. There are larger formats such as 5x7in and 10x8in, all of which produce exceptional image quality, and the visual impact of the images is one of the major advantages of large-format cameras for architectural photography. However, these cameras are generally heavier to carry and, particularly in the case of 10x8in cameras, expensive on film.

The design and construction of view cameras is very simple, even though they look complicated. The skill comes in using the various camera movements (see page 37) and knowing how each affects the image. The principal of a large-format camera is basically simple, but in practice requires concentration, which takes away much immediacy. The 5x4in camera system has the flexibility to use rollfilm

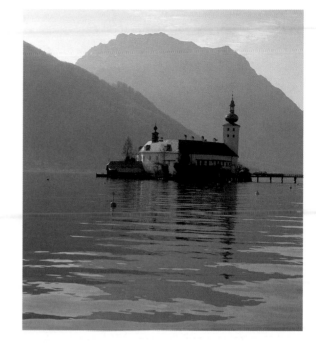

▲ **Medium-format cameras are also a more realistic option than large-format models when it comes to travel photography such as this image of Seeschloss Ort Castle, Gmunden, Austria.**

📷 Mamiya RZ67, 1/125sec at f/11, ISO 100

backs and a wide selection of lenses, which are simply clipped onto the back and front standards of the camera.

These large-format cameras normally use sheet film, which is loaded into dark slides giving two exposures per dark slide. The large image size offers an exceptional tonal range for obtaining excellent quality for reproduction or manipulation. There are digital backs, which can be attached to film large-format cameras or integrated into the camera system as standard. The advantages for architectural photography are that the standards can be moved offering unparalleled opportunities to control the lens-to-viewfinder distance and the ability to manipulate the image as well as correcting distortion. The movements allow the photographer to adjust the image and

composition and are known as rise and fall, tilt and shift, which are in turn governed by the focal length of the lens. Movements control the plane of focus and to alter the appearance of perspective.

Basically, large-format or view cameras consist of a back and front standard that are usually L- or U-shaped, one holds the lens and the other holds the viewfinder. The two are joined together by a bellows, a flexible material, which expands or contracts as the lens is moved up and down on the monorail or baseboard connecting the two standards (monorails are more common). Lenses are attached to the front standard by a panel, which is either recessed for wideangle lenses or flat for the longer focal lengths. The image is viewed on a ground-glass screen and usually seen reversed and inverted, which can be considered a disadvantage. There are also binocular attachments available for each camera system, designed to reverse the image again so it is the correct way up, but it soon becomes second nature seeing the image upside down.

The ground-glass viewfinder and lens panel are attached by clips, allowing them to be easily removed or rotated depending on the format of the image required. The glass on the viewfinder is usually etched with a grid and spirit levels attached to the front and back standards help with the alignment of the horizontal and vertical axis of the image. The grid lines are an excellent aid for composing the image and aligning the vertical and horizontal aspects of the subject being viewed through the back of the camera.

A larger image means higher resolution, though a lot of quality depends on the film and lens. There can be some compromise when a rollfilm back is fitted to the back of a large-format camera, but the main advantage of using a rollfilm back is that the photographer can still use the camera movements of the large-format camera and expose more frames in one sequence instead of changing dark slides for each shot.

Large-format cameras are too unwieldy to be hand held and have to be mounted on a sturdy tripod. As a result they are not suitable if spontaneity and speed of movement are required, but the quality of the final image usually outweighs the disadvantages of large-format cameras.

▶ Large-format cameras possess two standards, one which holds the lens and the other the viewing screen. These can be moved to provide a large-format camera with its main advantages: the ability to control perspective and depth of field.

TOOLS OF THE TRADE

Camera movements

The main advantage of large-format systems for architectural photography is their ability to correct the converging verticals of buildings, even when the camera body is tilted upwards or pointed downwards. There are very few architects or builders who design buildings with leaning walls – one of the exceptions to the rule being the Spanish architect Antoni Gaudí, who designed his buildings with elaborate curves and ornamentation rather than straight lines – but generally the walls are supposed to be upright and straight without convergence. Besides their basic capabilities large-format cameras introduce a degree of creativity and control in the form of camera movements, which gives the photographer the ability to control shape, sharpness and perspective. The main purpose for these cameras in architectural photography is to keep the buildings upright and the walls straight.

There are four basic camera movements;

1 Front shift – The lens moves from side to side or up and down parallel to the film plane.
2 Front tilt and swing – The lens pivots up and down or side to side around its optical centre.
3 Back tilt and swing – The ground glass can be pivoted.
4 Back shift – The ground glass can be moved up and down and side to side.

The key function of camera movements for architectural photography is to correct converging verticals. This involves making sure the subject and image planes are parallel and is helped by aligning the straight building edges with the grid lines etched on the ground-glass screen and using the spirit levels attached to each standard. Once the back of the camera is completely parallel with the subject, front shift is applied to bring the whole of the subject within the frame, unlike what is necessary with other cameras where in most cases you must tilt the camera in order to fit in the top of the building.

Converging verticals are usually associated with looking up at a building, but they can occur when looking down and raising the back standard or lowering the front standard can correct them. There is a limit to how far you can raise or lower the lens standard as eventually the bellows will limit the light from the lens and cause vignetting or cut-off part of the image.

It is also possible to alter the depth of field by using camera movements. You can control the sharpness of an image, in addition to using the aperture, by tilting or swinging the front standard or rear standard to align the plane of focus with the subject plane. In conjunction with narrow apertures it is possible to achieve an extremely large depth of field by tilting either the rear standard or lens standard, but using the two movements together will cause a certain degree of distortion.

Because depth of field extends one third in front of and two thirds behind the point of focus I tend to focus one third of the way into the image and tilt the lens standard forward by about 5° to make sure the foreground is sharp. It is not much of a tilt but it does make a lot of difference to the depth of field, especially when a narrow aperture is used to increase the overall sharpness; such a small tilt does not change the perspective.

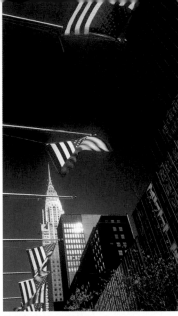

© **Jon Hicks, FBIPP,**
email: jonhicks@cheerful.com

Panoramic cameras

While a digital image can be stitched together using Photoshop or a specialist piece of software, film panoramas rely on highly specialized cameras (unless you scan your images, which has its own pitfalls). These cameras can add a creative edge to your portfolio. Creativity is, after all, about change and breaking away from the standard, and they do this by offering a wider aspect ratio than the standard frame. Two examples of such panoramic cameras are the Fuji GX617 and the Hasselblad XPan, although both are now discontinued, but they can be found secondhand. These cameras, with the exception of the XPan, use medium-format film and produce a large image. However, the consequence is that they are relatively bulky and

cumbersome, and need a tripod if they are to be aligned properly. They can also be very expensive on film, as only a few panoramic frames will fit onto a single roll.

Also available are specialist panoramic backs for large-format cameras. These most commonly create a 6x12cm image, and if you use a large-format camera anyway they may prove to be a cheaper investment than a separate specialist camera. However, before you are seduced by the impressive results that can doubtless be obtained with a panoramic camera you should consider whether the highly specialized nature of the images will actually be worth the expense and inconvenience of a new camera system.

◀ ▼ **Panoramic cameras enable you to break away from a more conventional format, bringing something a little unusual to your photography both in the vertical and horizontal format. The shots of New York, left, and the Bristol waterfront, below, are examples of this. However, panoramic cameras are relatively expensive and are a very specific tool.**

Opposite: Details not recorded
Below: Hasselblad XPan,
1/125sec at f/11, ISO 100

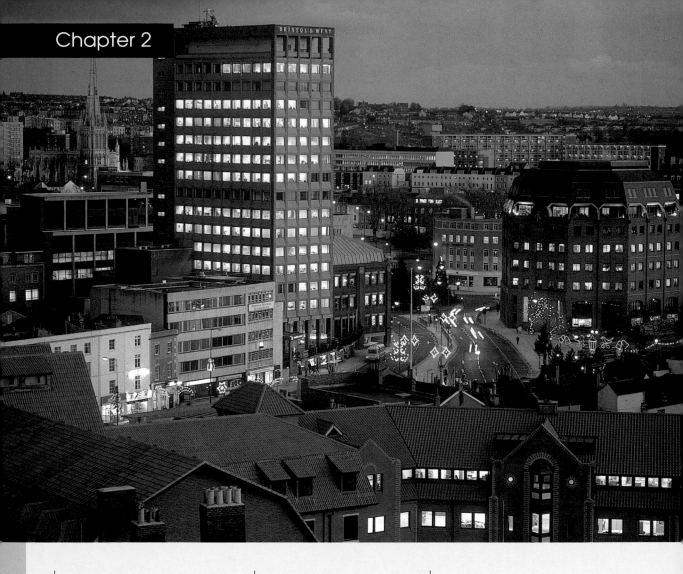

Lenses and accessories

Each camera system has a range of lenses and accessories suitable for a variety of subjects, including architectural photography and it is up to the photographer to choose the relevant ones. The lens is probably the most important element of any camera system, as it is through this that the light passes to form an image on either the film or sensor, making the quality of the lens crucial to the final image.

The choice of lens that you make is critical in that it will affect not just the quality of the image, but also how the subject is represented. Other accessories also have a critical role to play.

Lenses

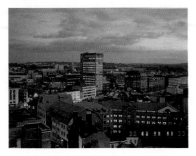

◀ ▲ **The lens that you use to take an image makes a real difference to its appearance. Using a telephoto lens, left, will tend to make the central subject stand out more, while a wideangle lens, above, is normally more appropriate for showing a subject within its environment.**

Left: Mamiya RZ67 with 180mm lens, 1sec at f/11, ISO 100
Above: Mamiya RZ67 with 50mm lens, 1sec at f/11, ISO 100

It makes sense to purchase the best lens you can afford, as even with digital photography the lens dictates a large degree of the final image quality. Modern lenses are corrected for aberrations but it is still advisable to use mid-range apertures whenever possible to ensure optical errors, which can appear on the outer edges of the picture when the aperture is fully open, are minimized. All lenses have a fine coat of anti-flare material, which cuts down on the refraction of light as it travels through each section of the modern multi-element complex glass lens.

You will need to take a variety of lenses on a photo shoot in order to cover all eventualities. Short focal lengths give a wide angle of view, while longer focal length ones give a narrower one. This affects how the subject is represented within the frame, taken from the same point a subject captured with a wideangle lens will appear smaller than one captured with a longer focal length. A range of different focal lengths will be useful, either as a number of different single focal length lenses known as prime lenses, or in the form of a couple of zoom lenses that offer a focal range. Different focal lengths have differing effects and characteristics. These range from the subtle to the dramatic and if used properly in conjunction with the basics of exposure and composition can make a real difference to your images.

Standard lenses

A standard lens is one that gives the same sense of perspective as our eyes do; this means that the angle of view is very similar. Standard lenses give images without any optical eccentricities, this is useful if you wish to depict the subject in a straightforward manner, as it appears to the naked eye. That isn't to say that you cannot be creative with a standard lens; however, the primary use of a standard lens is to portray your subject in a natural way. Indeed, some photographers tend to use the standard lens for the majority of their work, especially interiors.

The focal length of a standard lens depends on the format of the camera that you are using. It is approximately equivalent to the diagonal measurement of the frame, for the majority of digital SLRs (those with an APS-C size sensor) this means a 35mm lens, while for a full-frame SLR or a 35mm film SLR a 50mm lens is standard. Standard focal lengths for medium-format cameras vary from 80mm for 645 and 6x6 format to 90mm and 120mm for 6x7 and 6x9 respectively, while 150mm is standard for 5x4in large-format camera.

Wideangle lenses

A wideangle lens gives a wider angle of view than a standard lens, and therefore the naked eye. This creates a larger field of view than a standard lens at any given subject-to-camera distance meaning that you are able to fit more into the frame. This can be very useful when photographing both interiors and exteriors, as you will often have to resort to a wideangle lens because of space restrictions.

It is worth noting that because of the smaller sensors that are employed on most digital SLRs a lens of a particular focal length will appear to be multiplied in comparison to the same focal length used on a 35mm SLR. Therefore the distinctive effect of a wideangle lens will be diminished when used on a digital SLR with a sub-35mm sensor, when compared to a film SLR. However, specialized lenses are available, providing extremely short focal lengths to allow for this effective multiplication.

It is worth noting that wideangle lenses can distort images. This can be used to emphasize the graphic composition of a photograph, but should sometimes be avoided, particularly if you want to take a more prosaic shot, or you have to meet the demands of a client. Using a very wideangle lens can cause geometric distortion, which results in irregular shapes of elements within the scene. If you want to capture as much of the interior as possible the best compromise is to select the longest lens that covers all of the significant detail within the scene, and position the centre of the frame in the middle distance. Alternatively, distortion can sometimes be avoided by only showing a portion of the subject and using it as a frame.

Wideangle lenses will tend to exaggerate the size of an interior, which, although visually pleasing, may be undesirable if you want to show a more accurate representation. However, used with imagination and a degree of care wideangle lenses can create dramatic and striking images.

If you use a camera that has movements (see page 37) these can be used to minimize and correct some of the distortions that may occur when using a wideangle lens. Similarly, various tools that can be found within image-editing software such as Photoshop can be used to eliminate these problems.

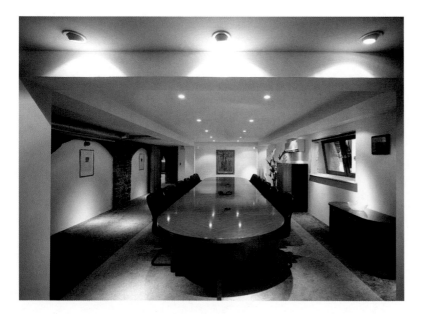

 A wideangle lens can be very useful indoors when you are restricted in your movements. If you are not able to step back any further then switching to a wider lens will enable you to include more of the scene in front of you.

🖸 Sinar X, 10secs at f/16, ISO 64

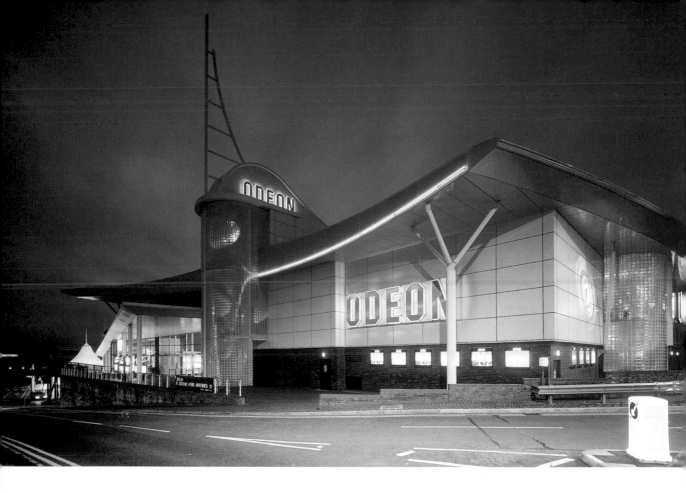

A subsidiary attribute of a wideangle lens is that its short focal length gives a great depth of field (see page 69) and by choosing a narrow aperture you can make a great deal of the scene appear sharp in the final image.

It is useful to have a selection of wideangle lenses, or to carry a single wideangle zoom to cover a range of situations. I frequently use a 58mm lens on my large-format camera in difficult circumstances, such as when shooting the cinema building above, where it was needed to fit in the whole building as there was a brick wall behind me and I couldn't move back.

The most extreme form of wideangle lens available is the fisheye, designed primarily for use on smaller-format cameras. The effects created can be very dramatic, distorting the image and increasing and exaggerating the feeling of depth and scale. Two types are available: rectilinear models that render the image within the rectangular frame, albeit with a 180° diagonal angle of view; and circular ones that have a 180° angle of view, but project it within a circle within the frame, leaving a black margin. However, despite its unusual properties, using a fisheye lens will not make up for a boring subject or bad composition.

▲ **Using a wideangle lens was a necessity in this situation as I was unable to move back any further as I had a brick wall at my back, and I needed a wider angle of view in order to capture the cinema within the frame.**

📷 Sinar X, 14secs at f/16, ISO 64

Case notes **2**

I was asked to photograph this new building in Cardiff Bay and try and come up with an eye-catching image suitable for a poster and brochure.

The first problem I encountered was the building had not been completed and there were workmen all over the site during the day. So I waited until dusk, when most of them had gone home, and asked the security people to switch on as many lights they could find that were working. I used a wideangle lens on my large-format camera and set up almost directly underneath the point of the structure which was above me. This wideangle lens has accentuated the point and made it appear longer than it really is, but I was looking for visual impact rather than a straightforward record shot.

The wind was briskly pushing clouds across the sky, so I used a shutter speed that was long enough to give the impression of movement in the sky and create some drama behind the static building. I placed a magenta filter in front of the lens which accentuated the pink colouring of the clouds and suppressed some of green colour cast from the neon lights in the atrium of the building.

Sinar X, 4secs at f/16, ISO 64

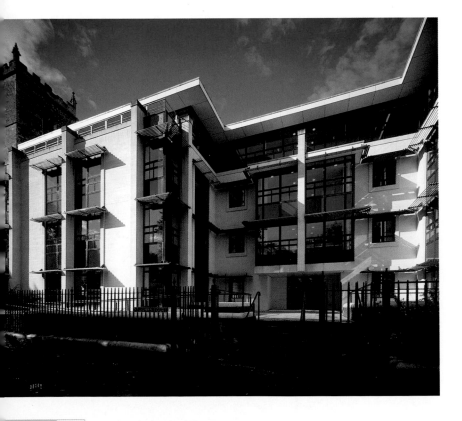

To a purist this picture is not accurate regarding the building's perspective, but it is visually strong and serves its purpose.

Sinar X, 1/30sec at f/22, ISO 64

Overleaf: Dynamic abstract shots are possible with wideangle lenses. GCHQ Building, Cheltenham, UK.

Mamiya RZ67, 1/60sec at f/11, ISO 400

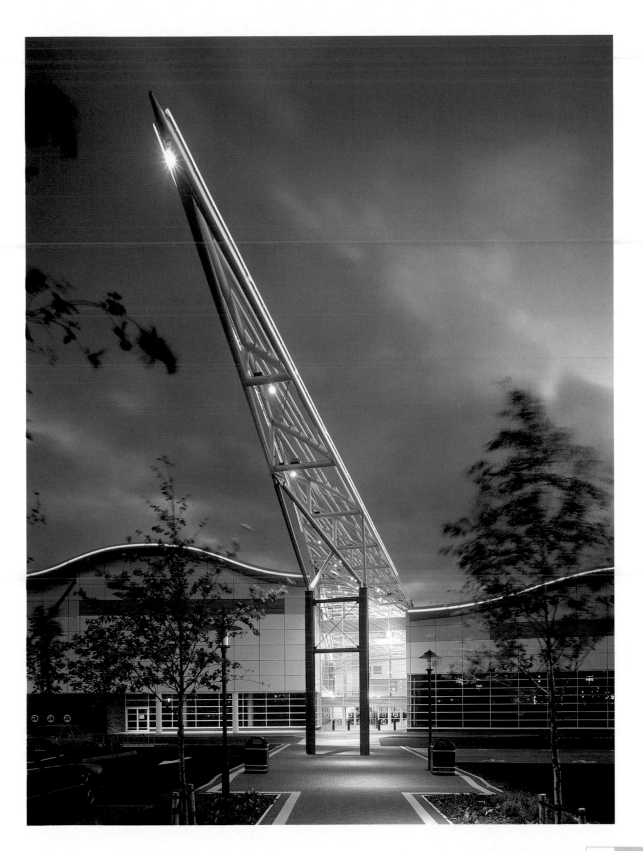

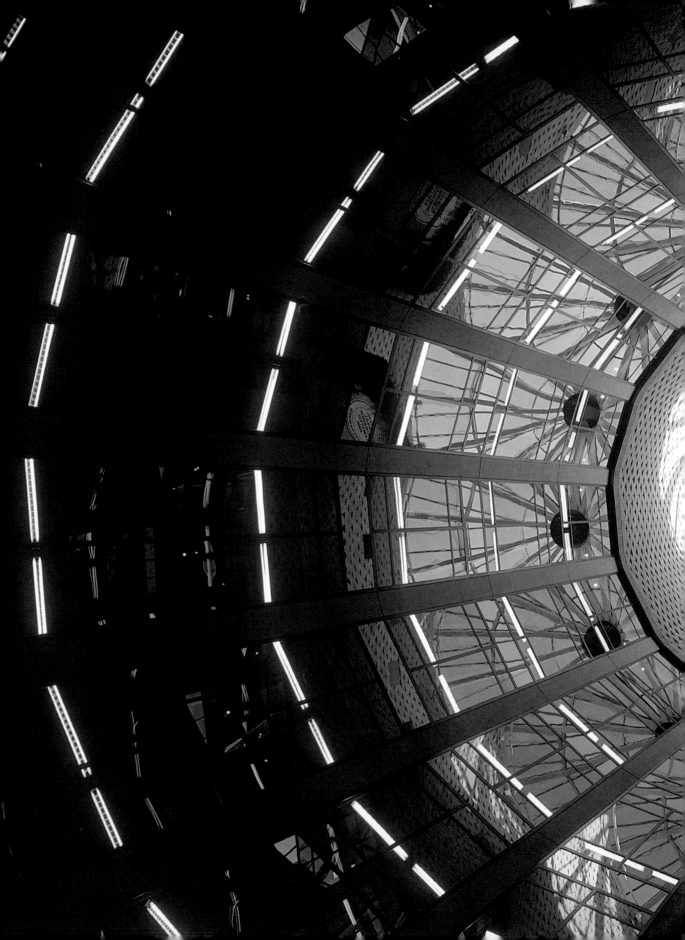

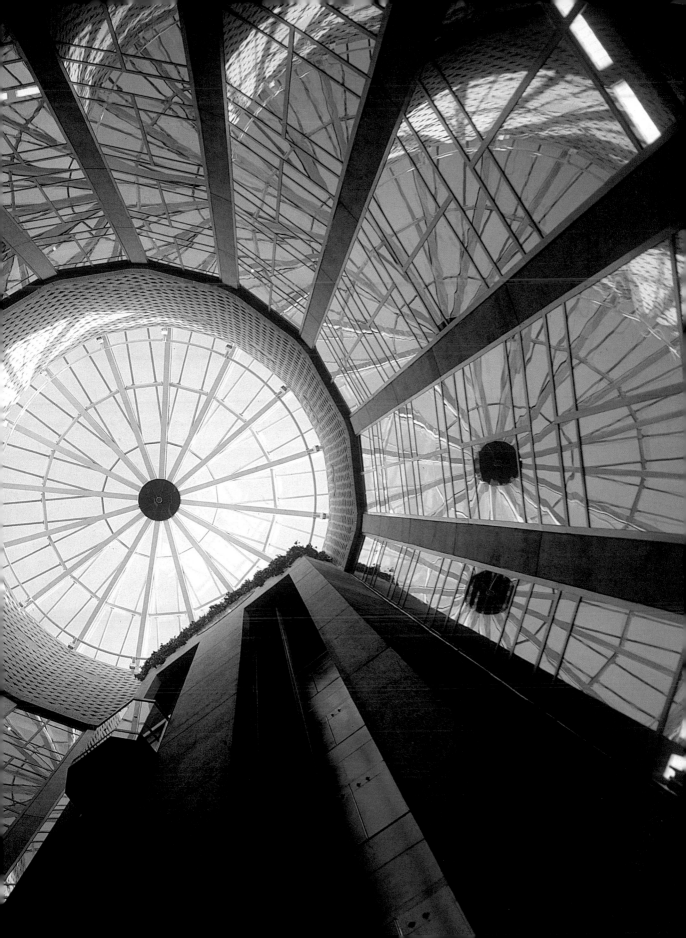

Coping with extreme wideangles

Caution has to be exercised when using an extreme wideangle lens, as they can cause distortion if the camera is used too close to the subject. Also when used with camera movements they can result in the bellows cutting off the light from the edges of the image area, resulting in a black half-moon shape at the top of the picture.

▶ ▼ **A telephoto lens used from a distance will compress perspective as shown in the shot of the French village to the right, while the sweep of the Millennium Bridge in London, England, below, has been exaggerated here by the use of an extreme wideangle lens in the form of a rectilinear fisheye lens.**

 Right: Mamiya RZ67,
1/125sec at f/8, ISO 64
Below: Mamiya RZ67,
1/125sec at f/11, ISO 100

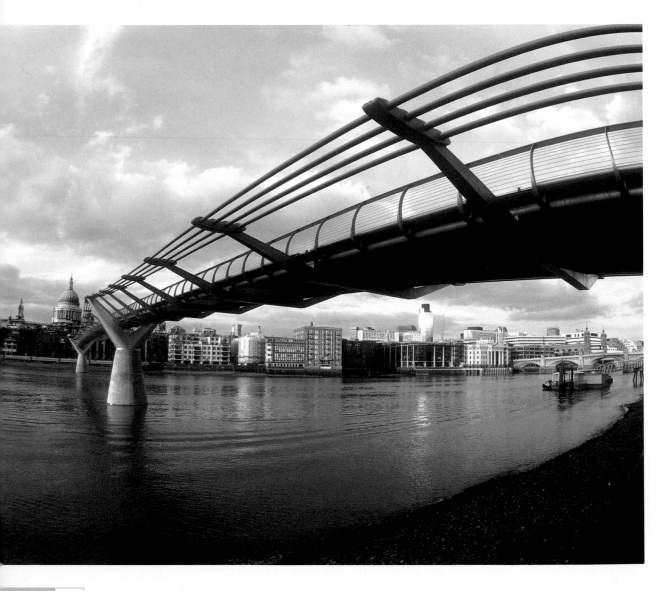

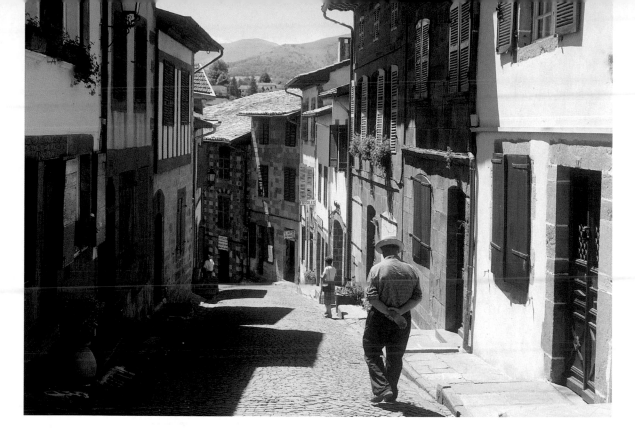

Telephoto lenses

Longer lenses, in other words those with focal lengths greater than the standard lens for that particular format, are known as telephoto lenses. They have an angle of view that is narrower than that of the naked eye, or a standard lens, and therefore represent subjects larger within the frame.

Telephoto lenses can be useful for a number of tasks, particularly for picking out such things as architectural details on exteriors or interiors. These can be made into attractive images in their own right or used to support a series of images of the building as a whole, with detail shots to add interest and colour.

Because of the increased distance from which a telephoto lens tends to be used telephoto lenses are normally associated with the compression of perspective, where the foreground and background elements of a scene appear to be closer together. Strictly speaking this is a product of the photograph being taken from further away, so in practice it

it only occurs when a telephoto lens is used from a fair distance. However, it can be useful if you wish to show objects in close relation to each other.

Relative to wideangle lenses a telephoto lens provides a shallow depth of field. Coupled with their narrower field of view and the foreshortening effect this makes it possible to isolate the main subject from distracting elements. This is particularly the case when using a wide aperture to create a shallower depth of field. However, you should bear in mind that the high magnification also results in a greater risk of camera shake and the longer the lens the more necessary a tripod.

The choice of lens is determined by what is seen through the viewfinder and how the final image is going to be reproduced. A variety of focal lengths, whether in the form of a zoom or a collection of prime lenses, gives the freedom to control the image and create a range of different images.

Film

As I'm writing this book, even in the age of digital photography, three new emulsions were launched at the PMA convention at the Orange County Convention Centre, Florida, USA. These new films show that there is still a long time left for film photography; they offer high colour saturation, finer grain and twice the sensitivity of the emulsions that they are replacing. Film will not die if photographers keep using it and should exist in its own niche alongside digital technology for many years to come.

There is a film, transparency or negative, monochrome or colour, to suit every architectural photographic assignment, and modern film can now deliver results that just were not possible before. As well as excellent colour fidelity, low grain and high resolution the new emulsions give superb greyscale neutrality, with a wide tonal range.

▲ Many people only think in terms of colour, but why not try shooting a black & white image in order to add a little variety to your portfolio. They can look very impressive, particularly when dramatic skies are enhanced by contrast filters as is the case above.

 Sinar X, 1/30sec at f/16, ISO 100

The film used for architectural work is usually dictated by personal preference, taste and criteria of the job in hand. All manufacturers market suitable emulsions for architectural photography and some will suit certain aspects and conditions better than others.

The colour saturation, consistency and film emulsion are important factors in the choice of film and this will only come with experience on location and prevailing light and weather conditions. Exposure, lighting, composition and the photographer's style can be influenced by the use of a particular emulsion or how it is processed, for instance cross-processing for creative effects in colour. It is important to make the choice of film to suit the location to match characteristics such as contrast, vibrancy with the subject, for example, strong colours for external views or the softer colours of tungsten film for certain interior photographs.

Films come in a range of different speeds that indicate their sensitivity to light. The more sensitive the emulsion is to light then the greater the speed, which is denoted as an ISO rating. Every time an ISO rating is doubled the film's sensitivity to light is doubled, meaning that the length of the shutter speed required to expose the film correctly is halved; while conversely, whenever a film's ISO rating is halved the length of the shutter speed required to expose the film correctly is doubled. A wide range of film sensitivities is available and, while each individual film has its own characteristics, slower films tend to have a finer grain, while faster ones tend to give a more atmospheric, but grainier appearance. This is often a look that is applied to reportage photography in black & white, but the smoother-grained, slower films are generally preferred for most architectural purposes. Even then these nominal speeds can be changed, and then corrected for by altering the development times they are given during processing, which is known as pushing and pulling.

The resolution indicates how well a film will reveal fine details in a scene and slow, fine-grained films have much greater resolving power than fast, coarse-grained films.

There are medium-speed films of around ISO 100, which are ideal for the majority of architectural work, as they have enough sensitivity to allow the use of correction filters for interior work (which diminish the amount of light entering the lens) and still allow a relatively narrow aperture to give a large enough depth of field for most exterior photographs.

The faster-rated films are most useful for working in low light levels such as dark interiors or in deep shadow areas outdoors, situations in which slower films would probably necessitate a tripod to hold the camera steady long enough to make an exposure.

With large-format cameras, where a tripod is essential, the choice of lower-sensitivity films is less important, but with small- or medium-format cameras that are usually hand held then faster films are often useful. The quality of modern film emulsions, even at the higher sensitivities, is superb and still shows little appreciable grain structure when very large prints are produced, often the most obvious flaw in faster films is just a slight loss in contrast.

The dyes used in colour film are balanced for a particular type of light during manufacturing. The most common film used in architectural photography is daylight-balanced film, which covers the majority of lighting situations. Most exterior photographs are exposed on daylight-balanced film and generally little or no filtration is needed, unless it is used for special effects. A large proportion of interior photographs are also shot on daylight-balanced film, usually in combination with colour-correction filters and flash lighting to correctly balance the available natural and artificial.

In some lighting situations it may be necessary to use correction filters and modern daylight-balanced emulsions will still produce good results with these, but you should experiment with some test exposures as this film is often not designed for long exposure times, and reciprocity failure (see page 72) could result in colour casts. Alternatively, tungsten-balanced film is available and will provide more accurate whites for much interior lighting.

While colour film is the standard choice for architectural photography, black & white film should not be disregarded. It is often used by professionals for special effects and fine-art architectural photography as well as supplementing any colour requirements, but there is no reason that an amateur cannot shoot solely in black & white.

Good black & white photographs can show off the designs, symmetry and shapes of buildings in their strong basic components, perhaps better without the distraction of colour. Certainly some of my clients prefer their projects to be photographed in this way and sometimes request black & white pictures of specific elevations and building details to be added to any photographic brief. Black & white negatives usually have more contrast in comparison with colour films and when used in conjunction with contrast filters, most commonly orange and red filters for exteriors, the results can be dramatic. Many black & white photographers process and print their own work, as it gives them a certain degree of control over the quality and creativity of the final photographs. The contrast and density of the negative can be influenced by agitation and temperature of the film as it is developed, while the choice of chemicals and materials also makes a huge difference; of course all of these are within the photographer's control.

Instant-print film is almost indispensable for large-format and medium-format cameras in architectural photography and is one of the most useful tools in complex lighting situations. Instant-print film gives a reasonably accurate rendition of the subject's tonal range and is useful as a guide for the final exposure.

Type 55 Polaroid film is worth a mention as it is a black & white instant-print film with a similar ISO rating to most tungsten-balanced film. Instant-print films are an excellent aid but should only be used as a rough guide to the final exposure as they may not have exactly the same characteristics as the final emulsion being used, even though they may have the same ISO number. This is particularly evident when long exposures are required and the problem of reciprocity failure occurs.

▷ **While black & white film tends only to be used to supplement colour shots by professionals on assignments amateurs have the luxury of be able to please themselves rather than a client. This means that you can use the medium of black & white to emphasize form and tone over colour.**

◻ Sinar X, 1/4sec at f/16, ISO 125

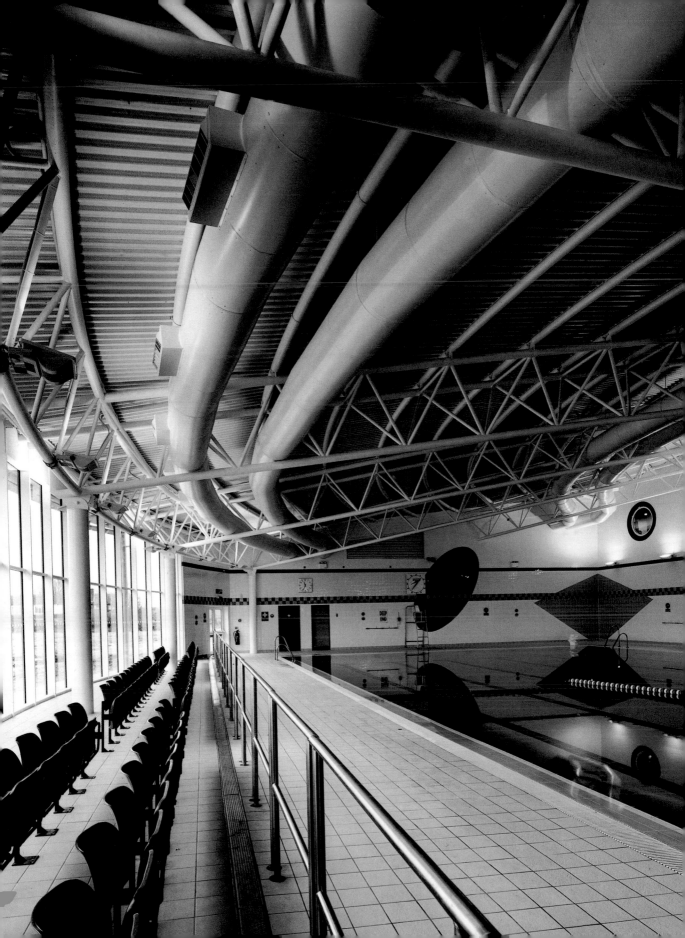

Case notes **3**

The warmth of the wooden floors and walls combined with the metal staircase results in a very strong and slightly abstract composition. The lighting was predominantly tungsten so I used a specialist tungsten-balanced film, Fuji 64T, to balance the colour of the light. The photograph shows the three floors, as well a glimpse of the corridor in the background. The composition gives a feeling of depth as the stairs take your eye up to the next floor.

📷 Sinar X, 5secs at f/16, ISO 64

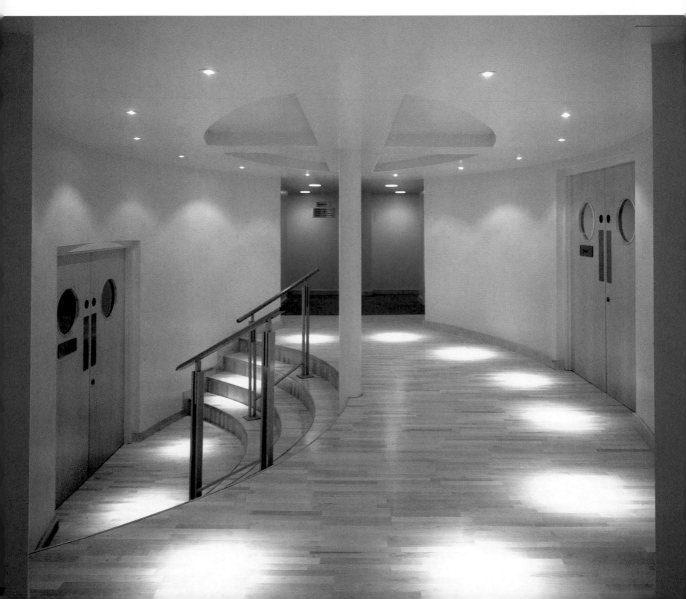

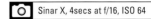
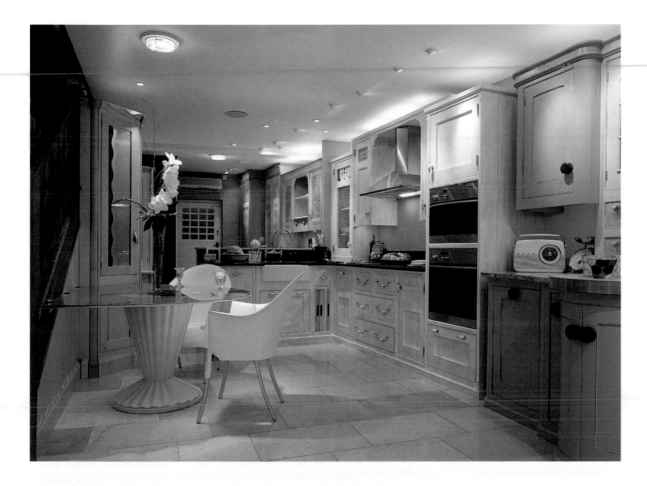

◀ Here the spotlights create the pools of light and the tungsten-balanced film has shown the daylight coming in the doorway at the end of the corridor as a blue square, adding an element of depth to the colour of the photograph. I knew in my mind's eye this was the effect I wanted to show and chose the film that I knew through experience would give the result I was trying to achieve, drawing the viewer's attention into the centre of the image. The grain structure is very fine and sharp and reproduced the colours accurately. This particular film emulsion is designed to record long exposures without any perceivable loss of quality due to reciprocity failure.

Toyo G, 8secs at f/16, ISO 64

▶ ▲ Sometimes it can be difficult to make the right decision as to which film to use as either can give an acceptable result. In this situation daylight-balanced film has given a cooler, but more accurate result, below, while tungsten-balanced film has given a warmer image.

📷 Top: Sinar X, 2secs at f/16, Kodak Ektachrome 64T
Bottom: Sinar X, 1sec at f/16, Kodak Ektachrome 64

Filters

Filters are used with the intention of altering the light as it passes through the lens. They can be used to compensate for the fact that film and digital sensors do not record light in the same way that the human eye does, as well as being used to add some creative effects. Within the context of architectural photography the most common use for filters is to correct colour casts from interior lighting. There is no substitute for the real thing, natural daylight, but used properly filters can offer corrective options, create moods, special effects and add drama to images by transforming straightforward subjects into something visually interesting.

In architectural photography there are a number of useful filters, which can influence the picture in many ways. Apart from the range of extreme filters that produce garish results, there are those such as polarizing, graduated and ultraviolet filters that are primarily used to enhance exterior photographs and colour-correction filters that are most commonly used for interiors. Most of the photographs in this book have been exposed using filters, even if it is just the UV filter over the lens to correct the blueness caused by ultraviolet rays present in sunlight. It is not always necessary to use a UV filter, especially in the case of interior photography, but it is useful to keep one covering the lens, both to reduce the haze in the atmosphere and as added protection from bumps and scratches. It is more cost effective to replace a glass filter than a very expensive camera lens.

Polarizing filters are used to reduce the glare, loss of saturation and reflections that can be caused by polarized light. The filter is dark in appearance and rotates once fitted in front of the camera lens until it gives the required effect. While this can reduce or eliminate reflections from shiny surfaces such as glass, water and marble surfaces it does not eliminate reflections from metals; a typical example of its use is to alleviate reflections on plate glass windows, where the filter is rotated until the reflections disappear. Polarizing filters also saturate colours and are often used to darken skies so that white clouds stand out prominently or to emphasize white structures on buildings in contrast to a deep-blue sky.

Neutral-density filters are also a useful addition to your kit bag. They are available in two varieties: plain and graduated. Plain neutral-density filters are used to cut down the amount of light entering the lens in order to increase the required exposure, enabling longer shutter speeds or wider apertures to be used in bright conditions. Graduated filters, on the other hand, are used to even out the tonal range of the image, most often between the sky and the buildings. Graduated filters are dark at one end and gradually become lighter towards the opposite end. The transition between the filtered and unfiltered parts vary from a gradual change (known as a soft-graduated filter) and a sudden change (known as a hard-graduated filter). Soft-graduated filters are generally useful for scenes where the sky requires a decrease in exposure, but there is no clear horizon line, while hard-graduated filters are more useful for situations in which there is a clear delineation between sky and subject.

TRADE SECRETS

Virtual filters

Many filters such as polarizing, graduated and ultraviolet filters still have a role within digital photography. However, colour-correction filters are largely made redundant as they can either be applied via the photofilter function in Photoshop or during the conversion of raw images.

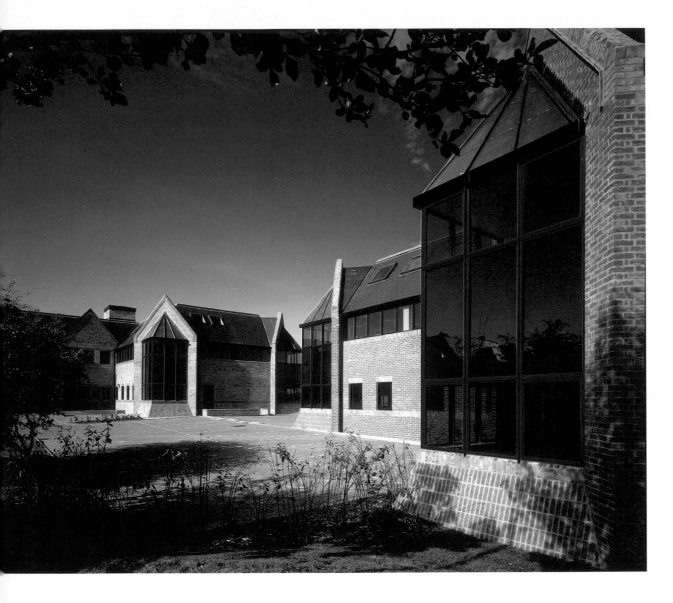

▲ Using a polarizing filter helps to
saturate blue skies. This can help to lift
a scene and helps to add colour to what
is an otherwise uninteresting building.

🔲 Sinar X, 1/30sec at f/16, ISO 100

These filters are available in a variety of strengths, and you can assess the one that you require by taking exposure readings from the sky and the subject. The difference between the two (exposure readings are explained on page 65) will be the strength of the filter that you require. As a photographer it never ceases to surprise me how many buildings are constructed facing north and unless the sun catches the front elevation in the early morning or late afternoon, then photographing from this angle can be difficult as the sun tends to face directly into the lens. I use a neutral-density graduated filter to reduce the glare of the sun and add detail to what would otherwise be overexposed.

While these filters are generally used for creative reasons to obtain a correct exposure, they can also be used in a professional sense, or even if you want to create your own combination of text and images for a website or portfolio, to underexpose skies in case text or copy has to be dropped on to the final image.

Finally, colour-correction filters can be used to balance the colours from various light sources, and these are covered in more detail on pages 115–124.

 Using a neutral-density graduated filter has helped to retain detail in the clouds; without this filter the sky and clouds would have been overexposed lacking detail and saturation. With the filter the image has a more balanced appearance.

Sinar X, 1/30sec at f/16, ISO 64

◀ ▼ A tripod is a vital piece of equipment. It provides the stability required to use heavier cameras and longer lenses by minimizing the risk of camera shake, while also proving to be a useful compositional aid.

📷 Left: Sinar X, 1/30sec at f/22 Below: Sinar X, 1/30sec at f/22

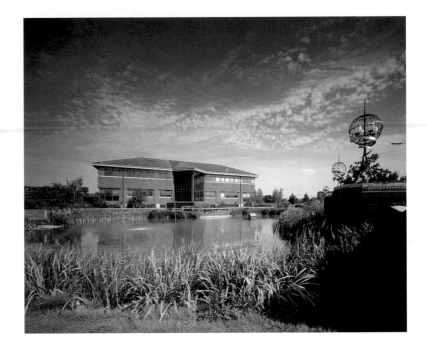

Tripods

A sturdy tripod is a must for most photography, but even more so for architectural work. Whatever camera you use there are very few occasions where a good tripod is not necessary. In most architectural situations the subject is lit by available light and although the photographer can add supplementary lighting the usual practice is to expose the subject using its own light, necessitating long exposures (see page 70). The heavier the tripod the sturdier it will be, and a good rule of thumb is that it should weigh approximately the same as the heaviest combination of items you attach to it.

You have a choice of tripod heads; the two main ones being ball-and-socket and pan-and-tilt. A ball-and-socket head is simpler, but a pan-and-tilt head offers movement in three axes and therefore more precision. Also, tripod legs should have non-slip feet and rubber shoes to prevent scratching expensive floors that can sometimes be found in architectural interiors.

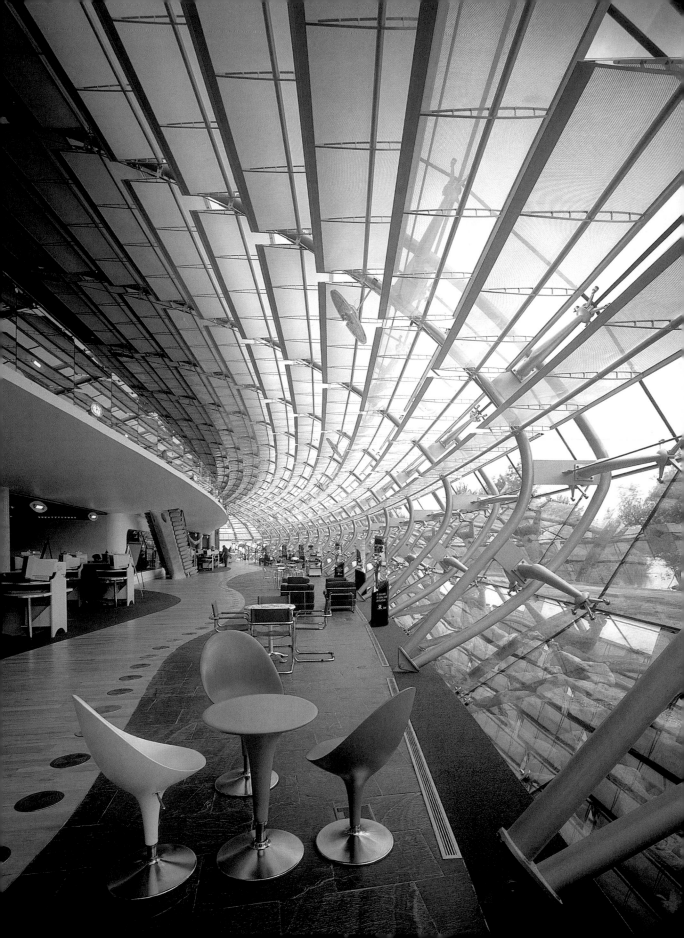

Technique and
Composition

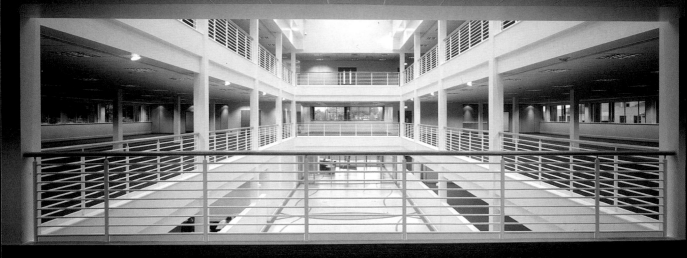

Light and exposure

Exposure is the foundation of any good image. You not only need to learn how to create an accurate exposure, but also how to manipulate overall exposure and the individual exposure variables to creative effect. Being able to do this will set your images apart from the crowd, but first you need to understand how to measure light accurately. Modern cameras feature a vast amount of automation when it comes to measuring, or metering, light; however, while relying on this will give you good results most of the time it won't give you that vital creative edge.

▲ Not all scenes are straightforward when it comes to exposure. This shot of an office building's atrium has a strong contrast between the shadows and the highlights, and learning to manage difficult exposures like this will be a sure way of adding impact to your shots.

 Sinar X, 3secs at f/22, ISO 100

▶ Understanding the relationship between exposure and the atmosphere of an image has allowed me to create a dark and moody shoot of Carreg Cennen castle in Wales.

Mamiya RZ67, 1/125sec at f/8, ISO 64

Exposure

There are basically two methods of measuring light using a light meter: by measuring light reflected from the subject or by measuring light falling on the subject (incident light). The most common method, in the field at least, is to take a reflected-light reading; this is taken by pointing your camera or a separate light meter at the subject while it measures the light bouncing off its surface.

Incident metering, the less common method of metering relies on measuring the light falling on your subject, and therefore on getting close to it. This is done with a specialist incident light meter, although some separate light meters can be used to measure both incident and reflected light. The need to get close to your subject means that incident light readings are more commonly used in studio photography, or for interior shots in the case of architectural photography.

Once a light meter has taken its reading it will recommend a combination of aperture and shutter speed for a particular film speed or digital ISO rating. Understand that this is a recommendation; a reflected-light reading is based on the assumption that the surface from which the light is reflected is mid-tone – a concept that is based on a surface reflecting 18% of the light that falls on it. This means that a reading that is taken from a subject that is not mid-tone will not result in an accurately exposed image. For example, a reading taken from a white wall, will be assumed by the meter to be from a mid-tone subject. The reading will reflect this and if you take the shot with those settings then it will be underexposed and rendered darker than it should be. Conversely a reading taken from a dark area will recommend an exposure that will overexpose it and render it lighter than it should be.

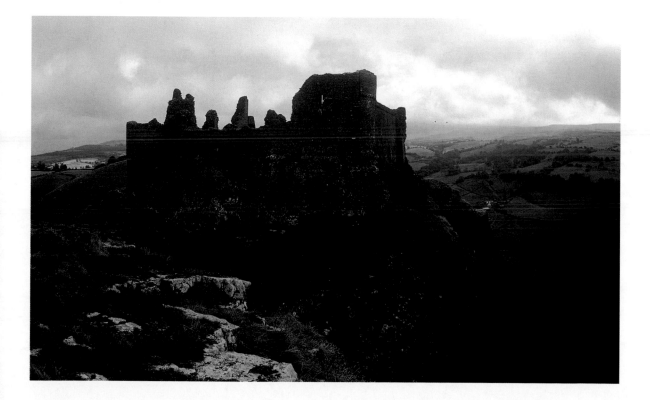

Case notes **4**

The simple converging lines of the reflection in this EU building in Brussels attracted me, and I shot it when the sun was low in the sky to capture the dramatic shadows. One of the best times to shoot architectural photographs is when the sun is low, either in the early morning or late afternoon. This can provide challenges to achieving a correct exposure, particularly if there are bright highlights contrasting with dark shadows, so make sure that the area that you meter from is a mid-tone area, then bracket your exposures (see page 72) to make sure that at least one of them is spot on.

📷 Sinar X, 1/30sec at f/22, ISO 100

Case notes **5**

The architect who designed this asked me to take a photograph of the main house from underneath this archway in the stable block. This elevation faced north, so the sun was directly facing the lens. It was late spring and the sun was still low enough to the horizon to cause unwanted flare at the top of the picture. I waited for some high cloud to diffuse the sunshine and then took my picture. After I had packed the camera away the house owner, who been standing beside me all the time, informed me that the view looked a whole lot better at night in comparison to the daylight shot I had just taken. He proudly informed me that he had only just finished installing lights all around the house and inside

the archway. I knew I could not leave until I had seen what he had done, even though it meant hanging around for a few more hours but as soon as I saw the lights come on I knew I had the image the architect wanted. Luckily he agreed.

Exposing for scenes with high levels of contrast such as this can be tricky as you don't want to lose too much detail in the shadows, but equally you don't want the highlights to 'blow out' and record as colourless white. Film tends to be slightly more forgiving than digital in situations such as this, but with film you should bear reciprocity failure in mind.

📷 Sinar X, 8secs at f/22, ISO 100

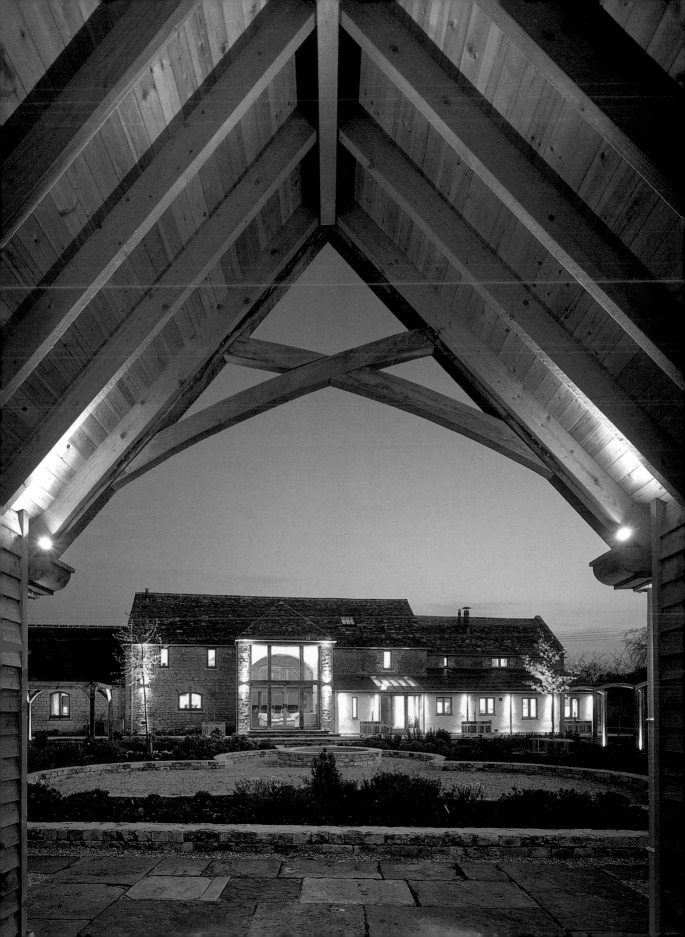

TTL metering

TTL metering, or through-the-lens metering, is a built-in exposure meter that is integral to all modern small-format cameras. There are many different types that the various camera manufacturers install on their cameras, but essentially they meter the light that arrives at the film or sensor plane through the lens. They then display the recommended exposure variables in the viewfinder display and on the LCD screen.

Having the meter 'in-camera' gives it several advantages, chiefly that it is measuring exactly the light that will hit the film or sensor, so any filters will be automatically accounted for.

The sophistication of a particular TTL metering system will depend on the camera it is a part of, but over recent years they have become progressively more advanced. Most are divided into a number of segments, some take note of the camera-to-subject distance while others include colour information. Most offer three different metering modes in which to operate: multi-segment metering, centre-weighted

metering and spot metering. Some Canon cameras offer partial metering, which is halfway between centre-weighted and spot metering.

Multi-segment metering will be known by different names on different brands of cameras, but essentially they divide the frame into a number of cells and take readings from each. These are given different weightings depending on where they are and include other information such as the subject's position. This is the default setting on most cameras and is suitable for the majority of subjects.

Centre-weighted metering takes the majority of its reading from the middle of the frame, then gives a lesser weighting to the rest of it; this is ideal for central subjects.

Spot metering is the most specific of the metering modes and it takes a reading from a small area of the frame, normally right in the centre. This can be useful when large amounts of the frame are not mid-tone and you want a reading from an area that is.

Case notes 6

I was on an assignment for a British lighting company photographing one of their big projects in the Netherlands and the brief was to show the diversity and quality of their retail lighting in this huge hypermarket. I had to come up with a front cover, which had visual impact and showed their lighting at the same time. Dusk seemed to be the best time to shoot the entrance and timing was crucial so I picked a time when neither the exterior or interior lights dominated the exposure. I used a wideangle lens and placed the camera dead centre and as close as I could without too much distortion, waiting for a suitable gap in the many customers who were still shopping, so I could expose the film for 15 seconds.

[O] Sinar X, 5secs at f/16, ISO 100

Exposure variables

The reading from your exposure meter will recommend a combination of shutter speed and aperture for a given ISO rating. However, these three variables can be altered and, provided that they still make up the same total exposure value, will alter the image's creative impact without changing its overall exposure.

Modern SLRs and compact cameras offer a wealth of exposure modes. Many of these completely automate the exposure equation, but while they are a good way of starting off they will not offer you the creative control you need. The most useful modes are: manual – the camera recommends an exposure, but you have complete control of the shutter speed and aperture; aperture-priority – you control the aperture and the camera selects the shutter speed; and shutter-priority – you control the shutter speed and the camera selects the aperture. Any of these modes offer you the ability to control exposure creatively.

ISO

The basis of the exposure equation is the ISO rating. This denotes the sensitivity of the film or sensor, and while it is assigned to a film during the manufacturing process – and therefore you are limited in you choice – a sensor's sensitivity can be altered. ISO ratings are simple to understand, a doubling of the value means that the film or sensor is twice as sensitive, requiring half as much light (either doubling the shutter speed or halving the aperture) to record the same exposure. Similarly, a halving of the value means that the film or sensor is half as sensitive, requiring twice as much light (either halving the shutter speed or doubling the aperture) to record the same exposure. Common ISO ratings start at around 50 (although there are lower-rated films available) and progress through 100, 200, 400, 800 and 1600 (again, higher rated films are available).

Aperture

The aperture is the hole in the lens through which light passes, this controls the amount of light hitting the sensor or film at any given moment. Apertures are denoted as f-numbers, this indicates the size of the aperture in relation to the focal length of the lens.

The aperture controls the amount of the image, from front to back, that appears sharp. A narrow aperture (a high f-number) will result in a large depth of field, while a wide aperture (low f-number) will result in a shallow depth of field. For example, f/8 is narrower than f/4 because it is one eighth of the focal length while f/4 is a quarter of the focal length.

It should be noted that the depth of field doesn't depend solely on the aperture; the focal length of the lens, the camera-to-subject distance, the point of focus and any camera movements applied to a large-format camera all play a role.

The shorter the focal length and the greater the subject-to-camera distance the greater the depth of field, while the longer the focal length and the shorter the subject-to-camera distance the shallower the depth of field.

It is worth noting that the depth of field, however large it is, extends approximately one third in front of the point of focus and two thirds behind it.

When you view a scene through a camera's viewfinder the aperture is normally wide open, this means that you cannot see the depth of field that will be available when the lens is stopped down to its shooting aperture. However, it is possible to check the depth of field by pressing the depth-of-field preview button on an SLR or by stopping down the aperture on a large-format camera. The problem with both of these methods is that the image becomes progressively darker as the amount of light available diminishes.

For most architectural photography the final image is usually pin sharp from the front to back; this requires narrow apertures and for the camera to be mounted on a tripod so that the slow shutter speeds do not cause camera shake.

Sometimes it is worth exploring different focus ideas such as isolating an architectural feature or even a building by ensuring it is sharp and letting the background drift out of focus. A wide aperture, a long focal length lens and shooting close to the subject can help achieve this effect, isolating the subject from distracting background clutter. Creatively the existence of an out of focus background or foreground gives the illusion of depth, even if the area that is unsharp has no detail it contains a slight element of mystery. By selectively using depth of field you can emphasize an interesting foreground detail into sharp focus against a blurred background, which just gives a hint of the environment, or you can bring attention to a middle distance subject within your picture by blurring both the background and foreground.

A picture can sometimes be made more interesting by careful use of depth of field rather than one offering plenty of detailed and stark information and which is basically a record shot of the subject in front of your camera.

Shutter speed

The shutter speed determines the length of time that the shutter is open, allowing light to strike the film or sensor. This is measured in seconds or fractions of a second. The creative effect of the shutter speed on an image is the way in which motion is recorded. A long shutter speed records motion as a blur while a short shutter speed 'freezes' it. This is far less complex than depth of field; however, you still need to realize that the effect of a particular shutter speed will depend on the speed at which the elements within the subject are moving. Subjects that are moving faster or are closer to the camera will require a shorter shutter speed to freeze their movement than subjects that are moving slower or are further away will.

Slower shutter speeds can be used to add an element of creativity to your images, capturing streaks of traffic trails at night or rendering moving people as indistinct blurs. This can add a little life and motion to what are usually stationary images of buildings.

▼ **The image on the left has a shallower depth of field because a wider aperture was used. This separates the main subject from the foreground and the background, while the shot immediately below was taken with a narrower aperture, ensuring that it is sharp from front to back.**

📷 Left: Sinar X, 1/500sec at f/5.6, ISO 100 Below: 1/30sec at f/22

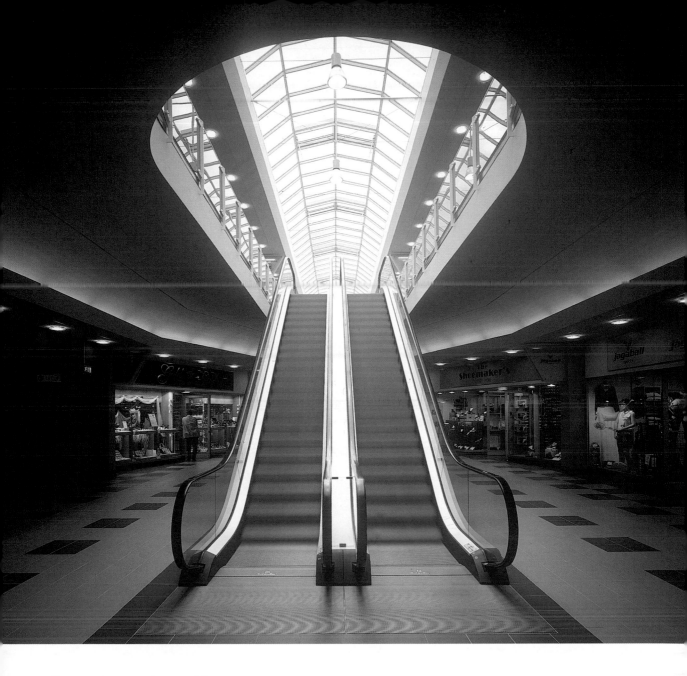

Case notes **7**

This image of a moving escalator in Berlin was required by an architect to illustrate a double-page spread. The shutter speed was carefully chosen so that it would be long enough that some movement was shown, but short enough so that the individual steps did not become indistinct. Trying to keep the highlight detail has meant that some shadow detail is lost, but I feel that this works well. The trick is to know in your mind's eye how the picture is going to appear and manipulating the exposure variables for that effect.

Sinar X, 1sec at f/16, ISO 100

Reciprocity

It is a key idea that an individual exposure variable can be changed, and provided that an equal but opposite change is made to another variable the overall exposure value will remain the same; this is known as the law of reciprocity. For example, a shot taken at 1/160sec at f/5.6 on ISO 100 film will have the same overall exposure as a shot taken at 1/80sec at f/8 on ISO 100 film, however, the change of aperture and shutter speed will give a different effect.

There are occasions on which the law of reciprocity can fail. When you are shooting exposures of over one second the properties of a film can change, often becoming less sensitive. This can effect the overall exposure and sometimes introduce colour casts as the exposure progresses. Each film responds in a different way and manufacturers will provide details of any filters or adjustments that are required to compensate. This problem doesn't apply to digital sensors.

Compensation and bracketing

There are certain situations in which you may want to alter the overall exposure value, either for creative effect or because you think that there is a reason that the meter reading might be wrong, for example, that the subject is significantly lighter or darker than mid-tone.

If you aren't using manual mode, in which you have complete control over the exposure variables, then applying exposure compensation (most cameras have an exposure-compensation button) is one way of altering the overall exposure value. Negative compensation will darken the image, useful for low-key shots or for avoiding overexposure caused by metering from a dark subject. Positive compensation will lighten the image, useful for high-key shots or for avoiding overexposure as a result of metering from a light subject.

An alternative method, which is best used when you are uncertain of the effect of the exposure, is to bracket your images. This means that you take one at the recommended meter reading with a series of images that are slightly over- and underexposed around it. This will give you a number of almost identical images that have slightly different exposures from which you can choose the perfect shot. You will have to bracket manually on some cameras, but many include an automatic bracketing feature.

◀ Once you have obtained the correct colour balance for the main light source in a room other light sources may register as non-white light. Far from being a problem this can actually create depth in the picture adding some creative impact so long as the supplementary colours do not adversely affect the overall colour balance, the results can be dramatic and pleasing.

🖸 Horseman LX, 5secs at f/22, ISO 100

The colour of light

While getting the basic exposure reading right is important, it is also vital to make sure that the colour of the light is correctly recorded, or at least looks pleasant. This is relatively simple when shooting on a digital camera as you will have the option to change the white balance; however, film users may find this a stumbling block.

While the various types of light appear more or less the same to the human eye, they can actually appear quite different once photographed. This is because light sources of different temperatures emit slightly different colours of light. This is known as the colour temperature and is measured in degrees Kelvin. This can be slightly confusing because light sources with a high colour temperature will emit white light that has a cool, blueish tinge to it, while light sources with lower colour temperatures will

▼ **In situations where it is important that the colour balance is correct, such as for business applications in the example of the office shot below, you can obtain the colour temperature from the light sources themselves and use this in conjunction with a filtration table supplied by the film manufacturer.**

 Sinar X, 4secs at f/16, ISO 100

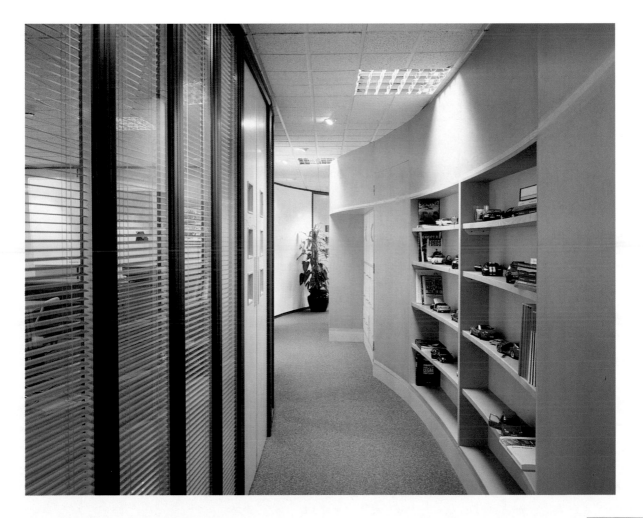

emit light that appears warmer, with a reddish-orange cast to it. Digital photographers can compensate for the various colour casts by altering the white balance, but film photographers will have to rely on choosing the right film and using the right filters to get the effect they want.

Colour and film

Different films respond to colour in different ways and often you will need to rely on filters in order to get the ideal result. There are subtle differences between each film's reaction to varying light sources, so it is wise to experiment until you find the combination to suit your style of work; however, it should be possible to work out the filtration by using the manufacturer's chart. In the end it comes down to each photographer's taste and this will only be found through experimentation.

An important group of filters for architectural interior work is the colour-correction filters. These are manufactured to correct light sources that do not match the colour balance of the film emulsion being used.

A colour-temperature meter is a useful piece of equipment for doing critical work under difficult lighting situations. The meter needs to be calibrated for either daylight- or tungsten-balanced film. You can compare different film and light readings by changing the film balance reading on the meter to find the film that needs the least filtration. The meter readings are usually taken using incident light, and they recommend a combination of colour-correction filters and film.

The reaction of some film emulsions may vary from the meter readings, so it is worth experimenting once you purchase a meter and keeping notes on unusual light sources for future reference.

▲ ▼ **Colour-correction charts, colour-correction filters and a colour-temperature meter are all vital items of kit for film photographers, enabling them to get the right colours in the final image for the particular type of film that they are using.**

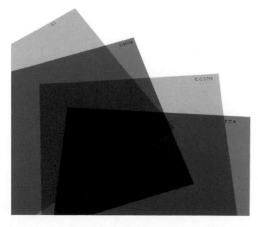

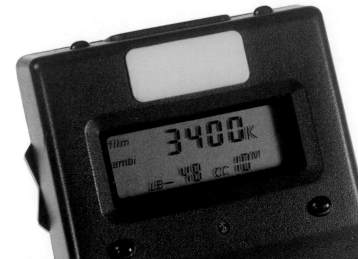

Case notes 8

It was important to show the true colours of the kitchen units as well produce a pleasing image. The main light source was daylight shining through the windows and a large glass door, just out of shot on the left at the bottom of the kitchen. The kitchen designer had pools of light created by the small tungsten lights recessed into the ceiling and these would affect the colour balance with a long shutter speed. The exposure time was set at one second and some fill-in flash, with a soft box attachment, was added to show detail in the foreground units. However, at one second the tungsten lights were strong enough to throw a slight colour cast on the kitchen units, so I added an 82C filter over the lens to take out some of the warmth from these lights.

Horseman LX, 1sec at f/16, ISO 100

▶ It is particularly important to gain an accurate reading of the ambient lighting in areas that are too big to be lit by supplementary lights, such as this engine plant.

📷 Toyo G, 5secs at f/16, ISO 100

▼ Be careful where you take your colour-meter readings from as it can be easy to meter the source nearest to the camera and not the overall key light. The light at the back of the corridor in this image gave the correct colour but the light in the foreground gave an untypical colour cast.

📷 Sinar X, 4secs at f/16, ISO 100

One problem occurs when the colour meter measures for predominately tungsten lights and if the exposure time is long the daylight coming in from small windows or doors can overwhelm the tungsten lighting in certain areas of the photograph. This can result in unacceptable blue areas in the picture. Even though the meter has correctly measured the overall lighting colour temperature as tungsten, the long shutter duration and the smallest amount of daylight within the picture area could alter the colour balance. This can be creative in certain situations, but not if accurate colour is important.

Colour temperature meters give accurate readings for most lighting conditions but are mainly calibrated for incandescent light sources. It is important to take great care which light source is being measured by the meter and appreciate the colour effects, which can be cast by other lights within the same room. The temptation is to stand by the camera and point the meter into the room you are photographing but this could be a mistake as the meter might only measure the light source nearest to the camera and not the overall key light. Experiment with different films and filters under mixed lighting and analyse the results.

Another problem occurs when measuring the ambient fluorescent lighting inside a room with daylight coming through the windows. The meter will give a useful guide to the filtration

necessary, or the tubes will be marked with their wavelength and temperature. Most film manufacturers supply useful leaflets showing the filters necessary to convert the light given off from the tubes to balance for daylight or tungsten film by reading the calibration markings written on the tube itself. These are usually shown as: cool white, warm white, cool or just white. Fluorescent lighting usually requires the placement of a magenta filter over the lens. This can result in a slight colour cast in the areas of the photograph showing daylight. Normally it's not too distracting, especially if the windows are in the far distance of the image but you should pay careful attention to the balance of colours throughout the whole scene.

A common problem faced by many photographers is large areas of glass, such as atriums and walkways, and it is a often good idea to add a magenta filter, as most large expanses of toughened glass are tinted and any exposure without this filter could result in a slight green colour cast.

Contrast filters for black & white photography are meant to transmit their own colour and absorb the others in the spectrum. The most commonly used in architectural photography is the yellow filter as it subtly darkens the sky and lightens any greenery. For more dramatic effects the orange and red filters are useful as they increase the contrast in the picture and almost blacken any blue sky, throwing light buildings and clouds into sharp relief. The visual impact can be very strong but the exposure time has to be increased accordingly (a TTL meter will account for this), as these filters cut down on the transmitted light.

Such contrast filters will also darken foliage, lighten brickwork and can add to your creative options by helping to transform straightforward subjects into images that will capture the viewer's attention.

It is good practice to keep the amount of filters placed in front of the lens to a minimum. I rarely use more than two, as the light passing through each surface is refracted and can degrade the image.

▶ **It can be tricky to balance the colour of a room which is flooded with daylight, as this can result in a slight colour cast. You should account for this when you are taking your colour-meter readings and compensate accordingly, reducing the amount of magenta filtration slightly.**

Sinar X, exposure not recorded, ISO 100

▲ Alongside the various filters that you will find integral to your work, such as graduated filters, colour-correction filters and polarizing filters, there are a number of filters that create special effects, including the starburst filter that has added the sparkle to the highlights on the edge of the bath.

📷 Sinar X, 1sec at f/16, ISO 100

Digital white balance

Balancing different light sources is less of a problem for a digital camera, as there is a white-balance function that allows the casts to be corrected. It is worth remembering that shooting in a raw format will allow you to make alterations to the white balance setting when you convert the raw file on computer. However, this isn't possible when you shoot in jpeg or tiff format.

While most digital cameras offer an auto white balance feature it is normally best that you set the white balance yourself. Auto white balance functions are generally fine outside, but begin to struggle under interior lighting, particularly when it is from a mixture of light sources. There are a number of ways to choose the white balance. The simplest is by selecting a preset mode such as 'fluorescent' or 'tungsten'; these balance the light to give natural colours under the stated conditions. Alternatively, you can dial in a specific value for the colour temperature in degrees Kelvin; this is useful if you know the colour temperature of the light source, so it will generally be restricted to those with colour-temperature meters. The third option is to create a custom white balance. This option can be selected from your camera's menu and will involve shooting a white or mid-tone surface under set lighting conditions. While it is a little more work, this can be particularly useful for situations in which the lighting falls between two of the preset white balance modes.

Finally, you should remember that the white balance on a digital camera, or indeed when you are converting raw files on computer, can be used to creative effect, not just to obtain precise colours. Try experimenting with the settings in order to create some warmer or cooler effects, you may find that they suit the subject better than the 'correct' white balance.

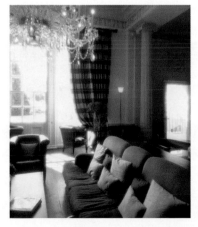

◀ **This hotel lounge is shown with an accurate white balance on the far left and a less accurate, but warmer and arguably more attractive cast on the right. Using the white balance to creative effect, either in camera or later on computer is a good way of adding atmosphere to your images.**

 EOS 1Ds, exposures not recorded, ISO 100

Composition

The composition of a picture is often intuitive and depends on how each photographer views the image through the viewfinder of his or her camera. There are 'golden rules', but the precise way each person sees a picture in their mind's eye is unique to each of us. This variety of styles is what makes composition vital, but also makes it difficult to teach. Effective composition directs the viewer's eye, holds it on key features and leads it away and back again. Look for elements that detract from the mood; once you have found your centre of interest, see if they lessen the impact and if they do, change your viewpoint. Ask yourself: are there lines, colours or shapes leading your attention out of the picture and away from the key elements? What is the functional space? How is it used? Does the building fit into its environment and convey the aura of a private space or an open public expanse? Am I composing the image in the viewfinder to show what my client requires? You should ask yourself all these questions and more. The secret of successful composition is that you consider all of the eventualities that arise in different situations, and for this reason this chapter concentrates mainly on practical examples, with a little theory thrown in.

▶ While you might feel that the best compositions are intuitive and that the art of composition cannot be learnt, this isn't true. The more that you practice and consider your compositions the better they become. Here, having considered the options available, I chose to highlight the strong sense of symmetry in the reflection by placing the vertical and horizontal axes of the image centrally.

📷 Sinar X, 4secs at f/22, ISO 100

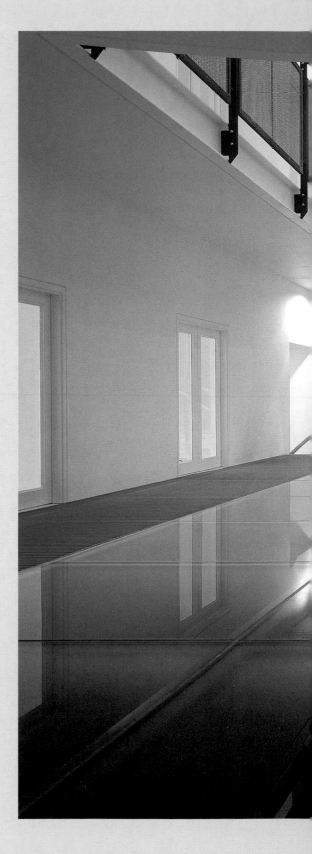

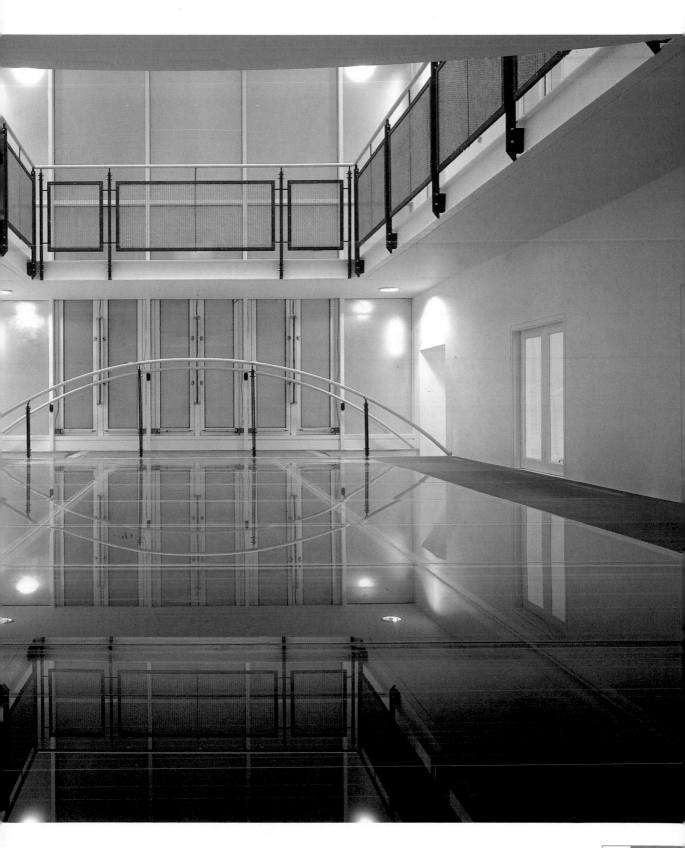

Case notes **9**

The designs of some buildings lend themselves to a less conventional approach. The repetition on the front of this building in Blackfriars, London, UK, was dramatically offset by the reflection of the building opposite in the stainless steel canopy above the entrance. The camera was positioned as near to the centre of the building as possible and tilted upwards. I used a wideangle lens to capture as much of the façade as possible and to emphasize the symmetry of the building's design. The narrow width of the pavement and traffic prevented me from stepping back and showing any more of the building's front elevation, but the angle shows a powerful image of a building in the financial district of central London.

[O] Sinar X, 1/30sec at f/22, ISO 100

Basic composition

Each photographer visualizes and composes images in their own style; even before picking up a camera they have some perception in their mind's eye how they are going to take the picture. Before pressing the shutter-release button, take a moment to analyse the scene in front of you and see if you could take an even better image; remember your vision is unique and it influences every picture you take. Only the way you see it will make it different and once you start thinking along those lines it is surprising how your photography starts to improve. The impulsive desire to shoot what is in front of the lens will be tempered by the realization that a better composition could be made with a little more thought and effort put into the composition stage.

Essentially, when we take a picture we are squeezing a three-dimensional scene into a two-dimensional frame; for this reason I and many other architectural photographers tend towards simplified designs, and attempt to avoid over-complicating the subject.

Once you have composed the picture in the viewfinder, start eliminating confusing elements around the subject by using the aperture to control the depth of field. This can help emphasize the key element by throwing the background out focus and concentrates the viewer's attention onto the main subject.

By its very nature architectural photography relies a lot on symmetry, and highlighting any symmetries can be used to exaggerate the form of a building. This can be enhanced by the selective use of lenses of different focal lengths and by the choice of viewpoint.

It is useful when framing the image in the viewfinder; to try and imagine yourself as the architect designing a project on a drawing board or computer screen and consider what he or she would record if they were in your place behind the camera. It is surprising what architects pick out as essential aspects of their buildings in comparison to what you would photograph if left to use your initiative, and if you are working for an architect this is why communication between the two of you is crucial. Even if you are only taking images as a hobby you can still try to get into the mind of the architect by reading up on the building, its history and its context, and I'm sure that this will help you to view the building in a new light, giving you plenty of inspiration for different ways of shooting it.

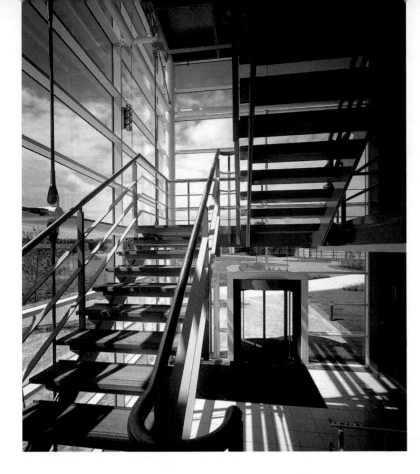

 Including a number of different planes will help to give your two-dimensional image the appearance of greater depth.

Sinar X, 1/4sec at f/16, ISO 100

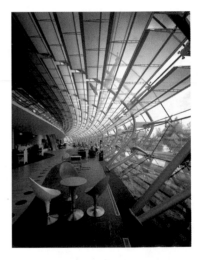

▲ Including some foreground detail, such as the chairs in the image above, is a good way of retaining a sense of scale and giving perspective to both interiors and exteriors.

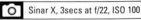 Sinar X, 3secs at f/22, ISO 100

Creating depth and space

The dominant physical aspects of the building are the keys to any composition, one of the most important parts of any building is the space within it. You can try and select a viewpoint showing two or three of the walls as this will create the illusion of depth. Two or three planes should define the space as multiple planes tend to reveal shape, structure and volume. If these planes include windows, or doors they can help lead your eye into other areas, thus creating depth and the illusion of a third dimension in your two-dimensional image.

To overcome the fact that images are captured in two dimensions, it is important to imply that there is a third dimension, that of depth. It is best to try and incorporate any lines or curves within the subject so that they lead the viewer's eye into the picture; the foreground can enhance the main subject and should lead the viewer's eye into the photograph and not distract from it.

The illusion of depth can also be created by the use of colour within the image, which can act as a frame or as a point of focus, while a wideangle lens and getting close to the subject, achieves a similar effect, although it can result in slight distortion.

Composition and light

The structure of a building and its relationship to light is a key part of any image. The way that light strikes a building will greatly alter the way in which it can be photographed effectively. The formation of shadows is very important as, although sometimes they are best excluded, they can often be incorporated in the composition.

The eye of the photographer, in other words a sense of design, the angle chosen to position the camera and the choice of lens are all key influences on the composition of a picture, and capture the play of light on a building. It is an appreciation of this that allows good architectural photography to transcend the simple reproduction of the building in front of you, and the following images show how I applied my particular style to various challenging situations.

▶ **Light isn't just important when it comes to exposure, it also plays a crucial role in composition as well. Different directions of light will cast shadows in different places and different qualities of light will make these shadows vague or distinct. Here strong sunlight helps to create a distinct shadow that I have used to help draw the viewer's eye towards 'Big Ben', London, UK, in the background.**

🄾 Mamiya RZ67, 1/60sec at f/16, ISO 64

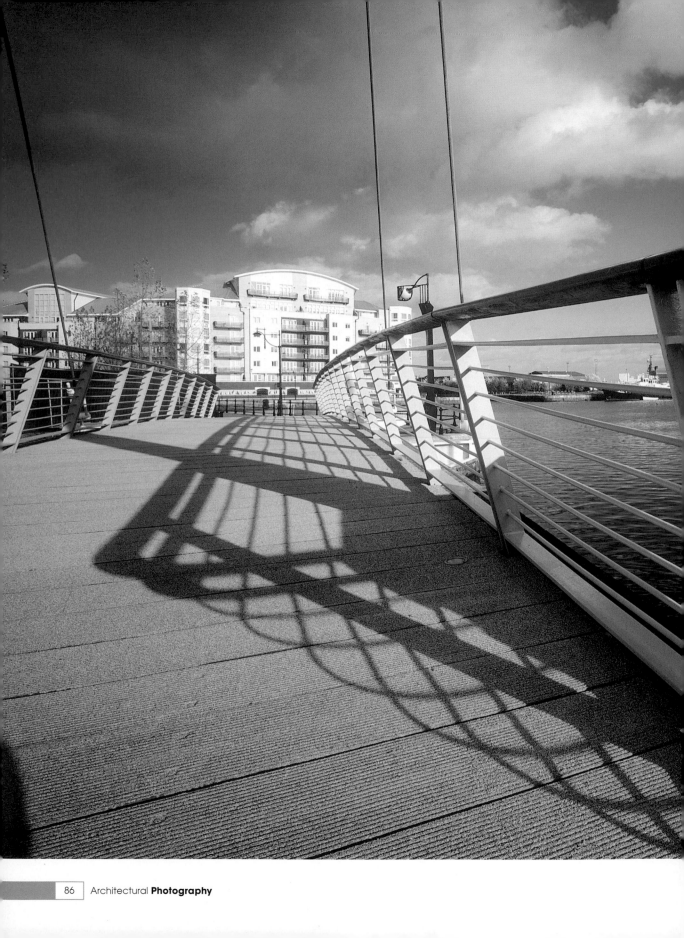

▲ There are plenty of geometric shapes in this modern office space. Creating a simple composition with the camera placed centrally has allowed these shapes to stand out without becoming overcomplicated.

📷 Toyo G, 3secs at f/16, ISO 64

◀ Adopting a low viewpoint is a good way of adding a little impact and drama to your images. This relatively simple bridge has had its lines exaggerated by placing the camera low down, which has allowed its lines to converge as they recede into the background.

📷 Sinar X, 1/30sec at f/22, ISO 100

Case notes **10**

The composition of this staircase in this ultra-modern office building in Swindon is highly symmetrical and needed to be illustrated. To achieve the correct position I placed the camera directly above the series of coloured lights recessed within the metal stairs. The lighting was mainly daylight, but I used a magenta filter to knock back the slight green colour cast from the neon lights in the office area on the right-hand side of the picture. The camera is tilted downwards and I set it up with the optical axis parallel to the metal struts in the foreground and floor at the top of the staircase. One problem I encountered was floor vibration every time someone used the stairs, which was often as it was the main thoroughfare to the canteen.

Sinar X, 3secs at f/22, ISO 100

◀ If you are shooting with only yourself to please then you can compose your shots as you like, with complete creative freedom. However, if you have to please a client you should bear in mind their requirements for the end use of the image. In this instance the cinema was shot with nice clean lines and empty spaces to make it easy to add text to the image.

Toyo G, 1/30sec at f/16, ISO 64

Case notes 11

Here are two images taken on a bridge leading to the Christ our Saviour Cathedral in Moscow, Russia. The composition of the first picture is very symmetrical as the camera is placed axially on the lines of recessed streetlights leading your eye directly to the subject. The second view was taken with the camera placed slightly off centre but still using the lights to draw your eye to the cathedral. Personally I prefer this image as it breaks the rules of symmetry a little, adding life to the composition.

📷 Sinar X, 4secs at f/22, ISO 100

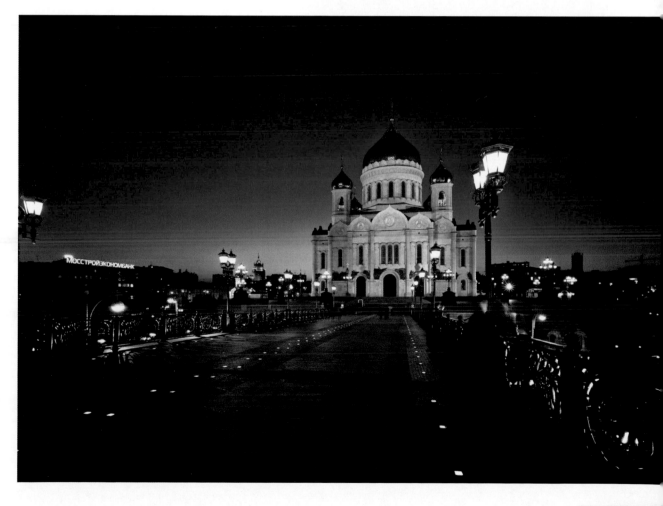

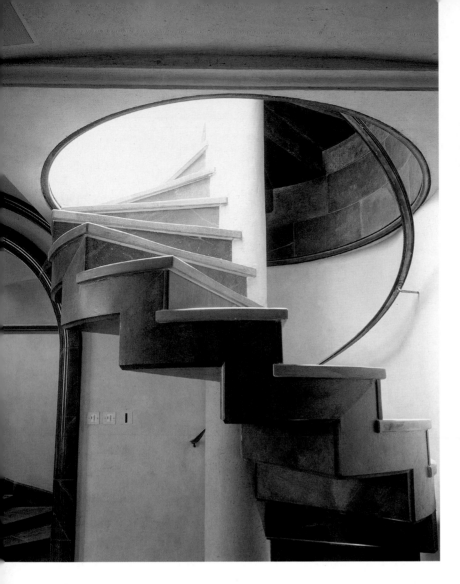

▲ Don't forget the role of light and shade in composition. While there was an obvious composition dictated by the shape of the spiral staircase the light at the top of the image has helped to enhance this, leading the viewer's eye upwards.

📷 Sinar X, 4secs at f/16, ISO 100

▶ Buildings with highly reflective surfaces can make for some really effective high-contrast compositions. This building, which is very popular with photographers is situated on the sea front in Cardiff Bay, Wales, UK, and faces west. I decided to try and capture the sunset reflecting in the glass and waited until there was a stormy day and a dramatic sky. Pictures like this require a lot of patience to wait for the right conditions, but the final result makes the effort worth it.

📷 Toyo G, 1sec at f/16, ISO 64

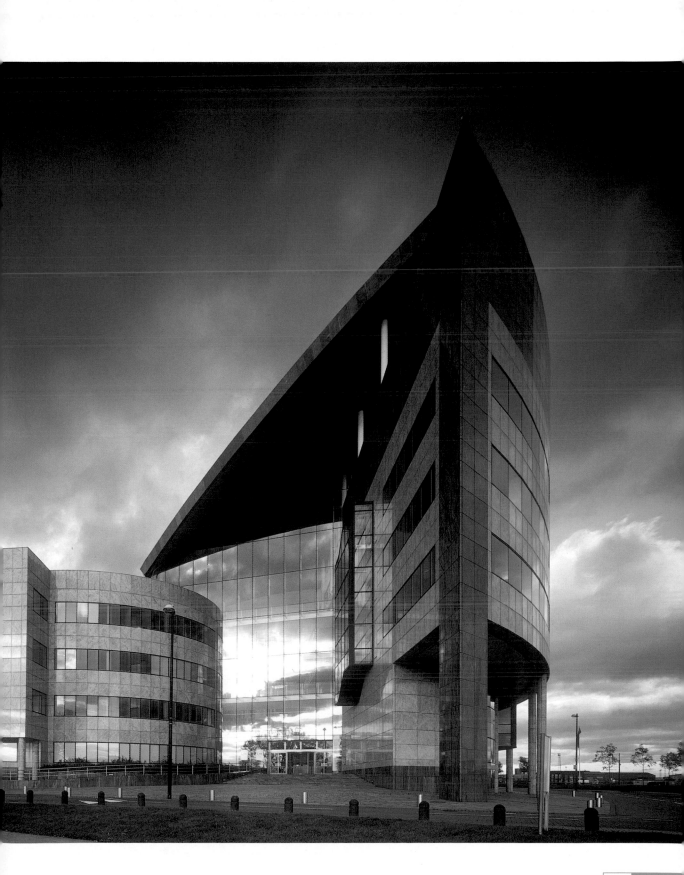

Case notes **12**

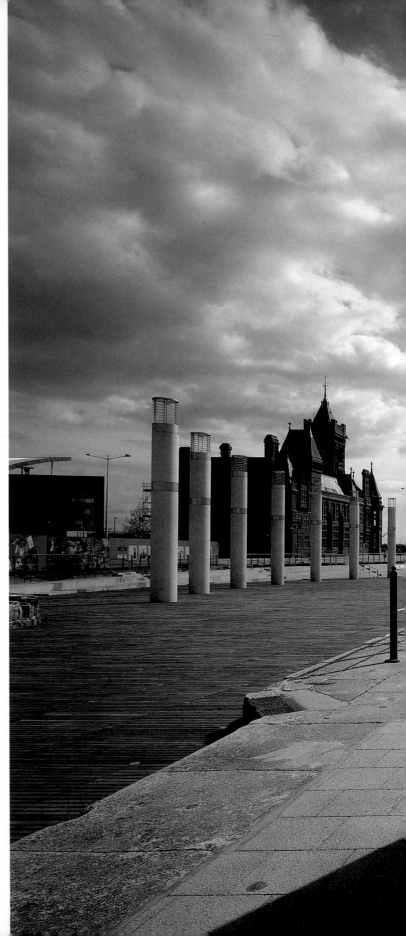

A scene or subject captured from an unusual position can have an exceptional impact, and a choice of viewpoint that departs from the conventional can help create a strong graphic composition. The purpose of most photographs is to attract the viewer's attention to the point of interest, and anything that interrupts uniformity or looks unusual will tend to hold their attention.

This image highlights the precise symmetry of architectural forms and design. Colour can sometimes dominate an image and spoil the subtler emotional content of a picture. Sometimes almost monochrome colours can result in an abstract, yet stronger composition. I photographed this building in Cardiff, Wales, UK, and used the stainless-steel side of a water fountain to catch its reflection. The camera was positioned as close to the steel plate as possible and facing directly into the sun.
A neutral-density graduated filter was used to tone down the glare from the sun and I also waited for it to disappear behind a cloud before releasing the shutter.

Sinar X, 1sec at f/16, ISO 100

Exteriors

Most photographers, professional and amateur alike, take architectural exterior pictures, as the subjects are generally more accessible and less demanding than interiors. There are very few people, with a camera in hand, who have not been inspired to photograph an attractive building at one time or another. The variety of buildings, their construction, shape and design, coupled with sunshine and blue skies offer any photographer a tantalizing wealth of subjects that are ideally suited to photography.

▲ Shooting exteriors normally means relying on natural light and sunset is one of the best times for photography. The warm rays of the sun help saturate colours and provide a natural vibrancy to images.

Toyo G, 1sec at f/16, ISO 100

I would love to say that every architectural assignment is exciting and glamorous, but unfortunately as a professional I have to take the rough with the smooth. A lot of my time is spent photographing uninteresting, empty industrial units or offices that are either for sale or available to let. I always seem to be given these jobs on cold winter days when the deadlines are tight owing to the fact the property agents start producing sales literature in time for the spring season. On these assignments it is not possible to have the luxury of being able to wait for the sun to be higher in the sky or the clouds to be less threatening.

If you have aspirations to make money from architectural photography then you should understand that this less-spectacular but equally challenging side of the industry will probably be your bread and butter. However, if you are an amateur then you have free reign to shoot whatever you like. Either way the main source of light for exterior photography is sunlight, which provides contrast, definition and texture. Light varies in brightness, direction and colour, and this in turn gives many opportunities when photographing architectural exteriors and, even to a lesser extent, interiors. Patience to wait for the right time of day, sensitivity to the changing light and picking the precise moment to press the button can turn an ordinary image into an extraordinary one.

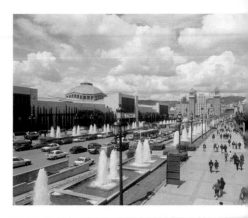

▲▼ There are a host of wonderful subjects that fall into the category of architectural exteriors. From the fountains of Barcelona, Spain, above to the almost surreal mixture of architectural styles and eras shown below in Swansea, Wales, UK.

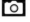 Above: Mamiya RZ67, 1/30sec at f/16, ISO 64
Below: Sinar X, 1/125sec at f/16, ISO 100

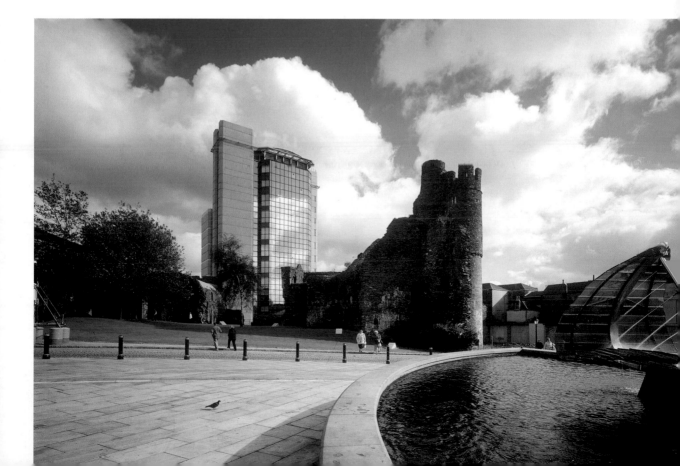

▲ While natural light dominates most architectural exteriors you can achieve some really spectacular colours by shooting subjects that are lit by artificial light sources.

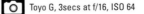 Toyo G, 3secs at f/16, ISO 64

Types of light

Daylight has different intensities, directions and colours and is often difficult to predict. When a building is lit directly by the sun it has hard-edged shadows, with high contrast and a variety of colours. However, clouds act as nature's diffuser by softening the daylight as it passes through, giving a gentler tonal range.

Front lighting generally gives little or no form, whereas sidelighting gives shape and texture. Sometimes backlighting can result in interesting images. There is no hard-and-fast rule that says you always have to photograph buildings with the sun in a certain position. Really it depends on how the sunlight interacts with the building's surface, whether it enhances or suppresses the texture and whether it picks out important details.

Including the environment

One of the main advantages with exterior photography is that often the photographer has the freedom of space and opportunity to choose the angles and locations to take his or her photographs. Obviously there are more constraints within built-up areas, due to narrow streets, traffic and high-rise buildings cutting off light to the subject at certain times of the day or year. However, photographing buildings on the outskirts of large towns and cities frequently offers more scope to include the surrounding environment. Builders, construction companies and architects like to show their projects as attractive places to live and work and in the majority of my instructions from clients I usually have to include some images showing the building within its environment.

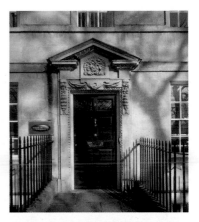

◀ ▲ **Different types of light suit different subjects. Above, texture is added to the façade of this building by sidelighting, while the modern glass structure, left, is complemented by the more dramatic effects of backlighting.**

Above: Sinar X, 1/30sec at f/22, ISO 100
Left: Sinar X, 1/30sec at f/16, ISO 100

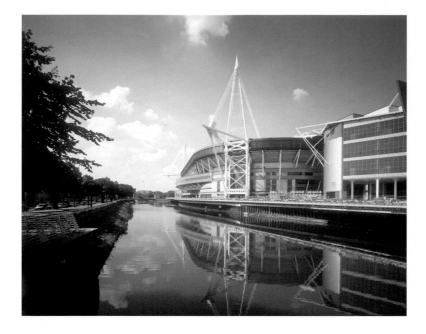

Many modern buildings are designed to be complementary to the environment that they occupy, and showing them in this light can bring additional interest to an image. It is important to include environmental details as part of a project portfolio to illustrate the integration of the building in its natural element, especially in regenerated urban areas, where the land may have been reclaimed.

▲ ▶ The Millennium Stadium in Cardiff, top, residential apartments in Canary Wharf, London, above left, office buildings in Reading, above right, and a windmill in Swindon, right, are all captured in a way that shows the landscaping that is so much a part of modern architecture.

📷 Top: Sinar X, 1/30sec at f/16, ISO 100; above left: Sinar X, 1/30sec at f/22, ISO 100; above right: Toyo G, 1/30sec at f/16, ISO 64; right: Sinar X, 1/30sec at f/22, ISO 64

While landscaping will never transform dull, uninteresting buildings into works of art the judicious use of plants, lakes and walkways strategically composed with your building can make them look far more inviting. This won't matter to most amateurs, who would never bother to photograph an ordinary-looking building, however, it is important to aspiring professionals.

Sometimes a building may not be very attractive and its key attraction is its location. Professional photographers should remember that people will accept unattractive buildings so long as they have access to a pleasant environment during their leisure hours, or at least have nice views from their windows. So it makes sense to photograph these views as well as the building itself.

When a building is uninteresting and difficult to photograph there are many ways of enhancing its appearance using the environment around it, try waiting for a dramatic sky or taking advantage of any trees and other greenery to act as a frame.

◀ ▼ **Three further examples of architecture in the context of its environment. You should be careful to maintain a good balance between the landscape and the building.**

Above: Sinar X, 1/30sec at f/11, ISO 100
Left: Sinar X, 1/30sec at f/16, ISO 100
Below: Sinar X, 1/30sec at f/22, ISO 64

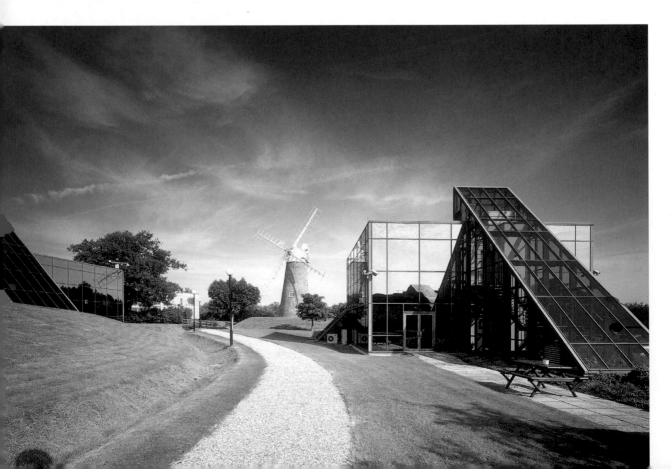

Photographing long, thin structures can also be very challenging, and while using a wideangle lens to cover the length will work, it also captures too much extraneous detail at the top and bottom of the frame. One way to cure the problem is to crop the final image; alternatively an interesting sky or a slightly different perspective can make even the most ordinary building look better. A slight caveat to this is that budding professionals should be sure that any photographs that emphasize the environment and not the structure do not give a false impression to any prospective tenant or buyer of the building.

If you are considering becoming a professional architectural photographer then you should remember that you will not have a free hand over what to shoot and you will be required to

▲ **Photographing the views from a building is also a good way of highlighting the landscape around it, as is the case in this shot of a harbour.**

📷 Toyo G, 1/30sec at f/22, ISO 100

capture key features. Car-parking facilities are one of the most important features for commercial buildings and at least one or two photographs are usually required to illustrate such an important selling point. Although these spaces are necessary for your client they are difficult to photograph with their full functionality visible yet attractive at the same time. The visual impact of such large, uninteresting areas can be softened with the careful use of walls and foliage.

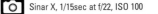 **Long, thin buildings present particular problems to architectural photographers. This is especially the case for professionals who may have to photograph uninteresting industrial units such as the ones above. Whenever possible try waiting until the sky is more attractive and then use a low viewpoint to exaggerate it.**

Sinar X, 1/15sec at f/22, ISO 100

Night and low-light shots

One way of overcoming the problem of photographing difficult buildings with very little daylight reaching them is to photograph them at night. Such photographs may not faithfully record every detail of the building but in terms of creating a mood and ambience, the advantages far outweigh the disadvantages. Although they are classified as night shots the photography is normally undertaken at dusk, when there is still some tone in the sky for the shape of building to show up in relief and detail and texture to still show on the building itself. Even small industrial units can be made to look interesting with night/dusk shots. The timing of dusk shots is critical; if the picture is exposed too early the visual impact is reduced and if it is left too late then the building

>>cont. p108

▶ **This shot of an unusual globe construction on Bristol waterfront in the UK shows just how much impact can be added to a scene by shooting it at dusk. The deep blue of the sky and the reflections of the artificial lights all add colour to the scene.**

📷 Sinar X, 6secs at f/22, ISO 100

 Shooting glass buildings against darker skies allows the interior lights to shine through. This shot of the Capitol shopping centre in Cardiff, Wales, UK is a good example of how waiting for the natural light to fade can help interior lights lift an image. While the RAC Building on the right has taken on a vibrant green hue that adds masses of impact to the photograph.

Left: Sinar X, 1sec at f/16, ISO 100
Right: Toyo G, 8secs at f/16, ISO 64

 Even small, industrial units can be made to look interesting when shot at dusk. Compare the drab and almost colourless image below with the one on the left; the building has been completely transformed by waiting for the right light.

Left: Sinar X, 5secs at f/16, ISO 100
Below: Sinar X, 1sec at f/16, ISO 100

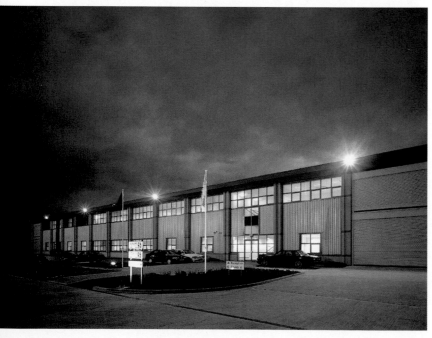

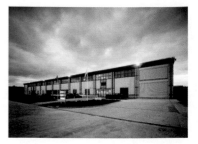

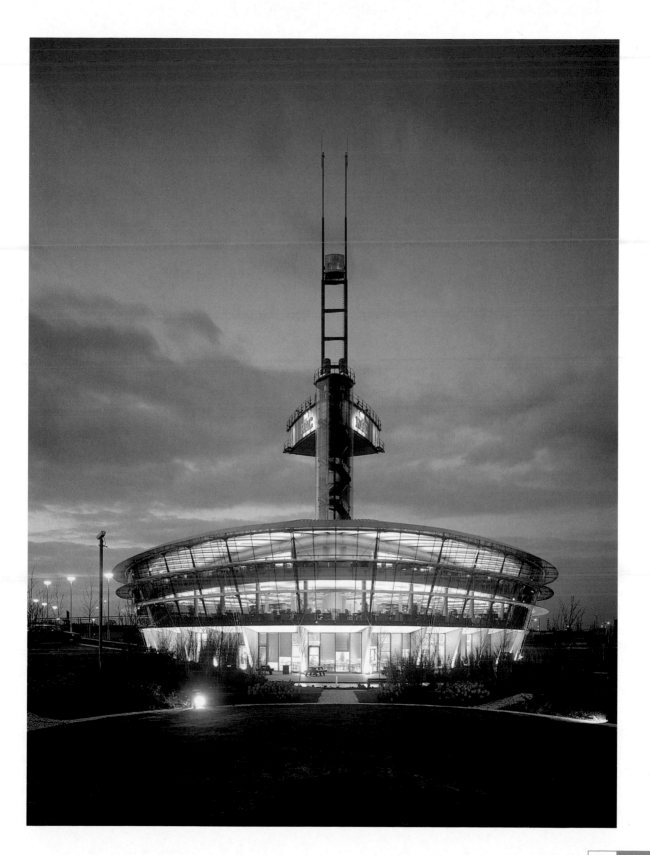

will appear as a black mass and its outline will be lost against a black sky, with a few squares of light from the windows and doors the only features remaining to be seen.

There is usually a window of approximately 20 to 30 minutes for night photography and timing is important. It is a good idea to set your camera up earlier than necessary and as the light drops take shots at intervals until it is clearly too dark.

Night photographs by their very nature can be dramatic, eye catching and have a strong visual impact. They are also a useful method of eliminating reflections on building surfaces that are difficult to photograph, such as glass and stainless steel. The use of backlighting in windows and doors at night helps create depth and interest for the viewer, and by using daylight-balanced film, dusk photographs can create an atmosphere of warmth inside a building. The interior lights appear yellow and orange, which adds to the mood and ambience in the photograph. Careful timing of dusk shots is important, as you want it light enough to record detail in the exterior of the building, but still dark enough for the interior lights to show detail inside the building without being too overexposed. I tend to wait until my meter, which is set for ISO 100, gives me a reading of 8secs at f/16.

Using a long exposure of approximately two to five seconds on windy evenings where the clouds are moving across the scene will cause them to appear slightly blurred behind the building, resulting in more expressive images, and showing nature in relation with manmade structures, perhaps even adding a bit of life to what would normally be a straightforward shot. A sturdy tripod is an essential piece of equipment on windy days and indeed for any long exposures.

Photographing buildings at night is not necessarily dependent on the weather, unless sunrises and sunsets are specifically required. In fact wet pavements on rainy evenings and the resulting reflections can add life to many a dull photograph.

Some photographers prefer to use tungsten-balanced film for night photography, especially when the sky is very dark and the exposures are longer. This film compensates for interior lights appearing too warm in colour and also records the sky area as very blue in comparison to daylight film. It is really a matter of personal choice and gives the photographer another useful creative option.

◀ Shooting Bristol waterfront UK, at dusk has added colour to the scene. The combination of deep blues from the evening sky and vibrant oranges and yellows from the sunset are duplicated in the reflections from the various structures.

Horseman LX, 1sec at f/16, ISO 100

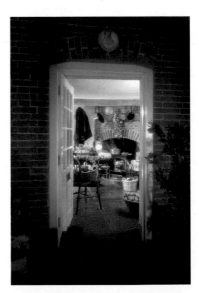

▲ These interior lights have recorded warm, while the exterior of the building is a cool blue, which has created a welcoming feeling inside.

Sinar X, 4secs at f/22, ISO 64

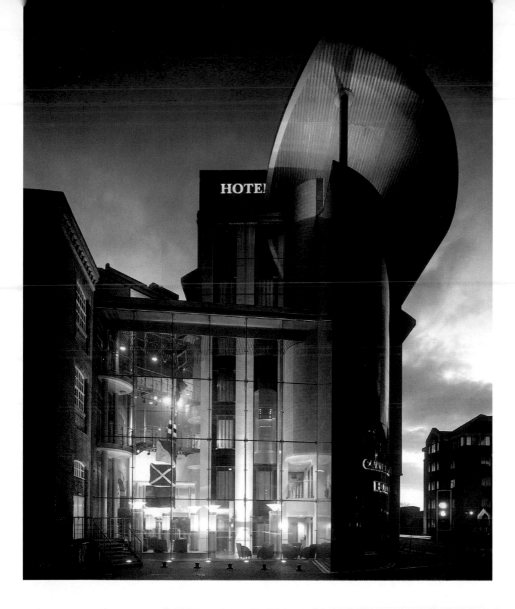

Case notes **13**

One problem most photographers have to contend with, especially on modern buildings, is reflections in shiny surfaces, such as window glass, mirrors and stainless steel. However, these do offer possibilities other buildings surfaces lack. Architects like to see the details behind large areas of glass and, although a polarizing filter over the lens will alleviate most of the reflections during daylight hours, one answer is to take the photograph at dusk. The image above is of a new extension added onto a hotel in Cardiff and by waiting until the evening the interior lights appear more prominent, while there is still enough light in the sky to distinguish the shape of the building against it. Here the lights behind the glass illuminate the interior of the hotel and at the same time kill the reflections in the window. A photograph like this is hard to beat when it comes to creating an atmosphere.

📷 Sinar X, 8secs at f/16, ISO 64

Converging verticals

Exterior photographs of tall buildings pose their own particular problems as, often, to capture the whole building from top to bottom, the camera has to be tilted upwards, resulting in converging verticals. Sometimes these distortions are visually strong and can complement a set of pictures but generally they are limited in their appeal for architectural work.

Even large-format cameras, with their ability to raise the lens on the front panel, are limited as to the amount of correction available before vignetting caused by the camera bellows cuts off the light reaching the film plane.

The ideal situation is to try and get back as far as practical and use a longer lens. Another solution is to find a building nearby and, if possible, take the photograph from at least one third of the way up the one being photographed, as this can also alleviate the problem, although it depends on access and permission being granted and is another example where pre-planning is crucial.

▲ **A passing car has left a streak of colour from its lights in the bottom third of the image. Effects such as this can be used to add life to any city or town scene at night, and are particularly effective with long streams of traffic.**

📷 Sinar X, 7secs at f/16, ISO 100

◈ TRADE SECRETS

Perspective crop

Photoshop possesses a useful tool that you can use to correct converging verticals. It is known as the perspective crop and it is a sub-feature of the standard crop function. You simply draw the crop marquee as you would for any crop, but then you click the 'perspective' check box. This allows you to alter the position of each corner point of the marquee individually. Adjust the sides of the marquee so that they run parallel to the converging verticals that you are trying to correct. Then, once you are happy with both your selection and the alignment of the marquee, click crop. This will cause Photoshop not only to crop your image to the marquee, eliminating any areas outside it, but also to interpolate the image to render it as a rectangle, thereby straightening the converging verticals.

▶ **The use of a longer shutter speed was not only necessary for correct exposure, but has also proved useful in allowing the clouds to blur slightly, creating a more ethereal effect.**

📷 Sinar X, 5secs at f/16, ISO 100

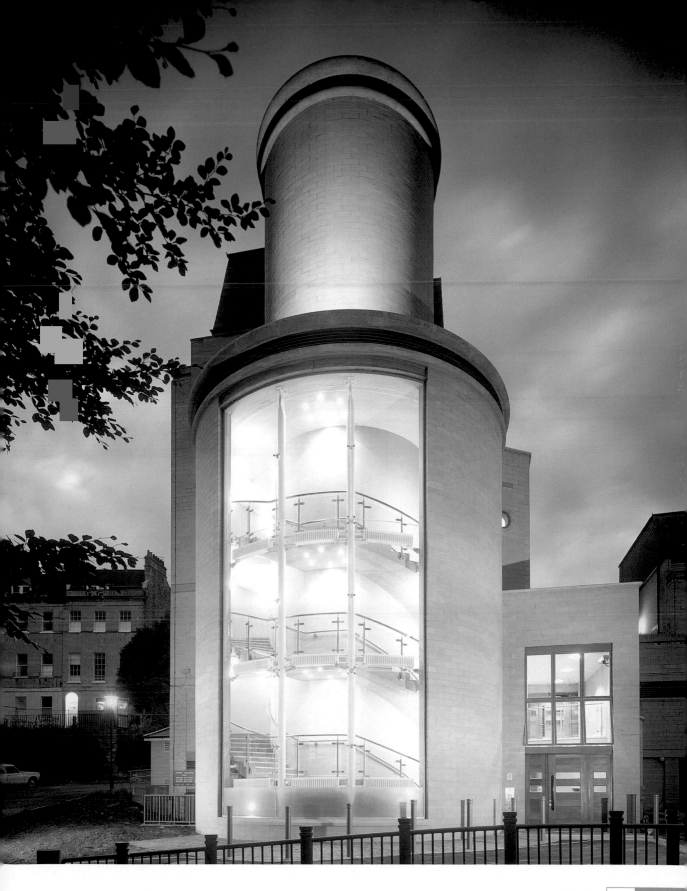

◀ Interiors have the potential to be very dull as rooms by their very nature are often dominated by the space within them. Focusing on details, and filling this space with foreground interest is one way of avoiding this problem.

📷 Toyo G, 8secs at f/16, ISO 64

Interiors

Most interior photography is carried out on location, which can be as diverse as public spaces, auditoriums, offices, industrial units and residential complexes. Interiors can be technically challenging but offer the photographer a lot of control in creating the final image as the only common dominator is the necessity for the lighting to look as natural as possible. There is less of a reliance on the weather, even to the extent that using artificial lights either on location or in a studio can create the effect of warm sunlight or whatever effect you wish.

Composing interiors

A problem with all architectural photography, but particularly interiors, is in distinguishing the various planes within an image to show depth in the picture. This is where analysis and of the lighting within the room itself and the decision to add any supplementary lighting is made. If the room is lit by mixed lighting but the dominant lights are fluorescent tubes, these may overwhelm the other lighting during a long exposure. However, by using Instant-print film it may be possible to control the overall intensity of the main lights by turning them off for a shorter period of exposure time in comparison to the other lights and thus allowing them to register or be filtered separately to add the extra dimension of colour and depth.

TOOLS OF THE TRADE

Portable lighting

While most exteriors rely on natural light to make or break the shot, a lot of interiors need to be complemented by supplementary lighting in one form or another. This is covered in greater depth in the chapter on artificial light starting on page 130. However, it is worth noting that the main thing that you are looking for in a lighting system is its flexibility. The ability to control the light in a number of different ways will help you gain that crucial creative edge, and while it might seem like a large outlay initially, a portable lighting system is, in my opinion, well worth the additional expense.

Before taking any photographs, make a note of the position, strength and colour of all light within the interior and remember shadows define depth. Over light the shadows and the shape of the room will disappear and appear artificial.

The challenge in interior photography is combining the main features of the room with its ambience without spoiling the design characteristics. It is very tempting to set up the camera in one of the corners, or the doorway, and photograph the room, without much thought to the lighting, a flat light giving a luminous ceiling without shadows, or composition but just endeavouring to shoot everything within the four walls. To a large extent there is a tendency to try and incorporate as much of the interior as possible, but there is a risk of the room looking lifeless. This does not mean that once the requested pictures have been exposed, you cannot try composing a better picture by moving the camera in tighter, turning some lights off or shooting cameo details, which can say a lot more about a room than a full shot trying to incorporate every aspect. Details can sometimes convey more information about an interior and its function than a shot of the whole can.

The most important feature in each picture is its emotional impact and the photographer should pursue that elusive aspect, as it is possible to do things with interiors by controlling the lighting, which could not be achieved to the same extent with exterior photography.

The shape of the room is important and the way light enters it dictates the camera angles that you should use, it also indicates the way in which you should use artificial light to augment the natural light. Given time and space with interiors you can almost do anything you like, within reason. You can create a dark, atmospheric picture by just exposing for the highlights and not adding any fill-in light for the shadows or conversely by exposing for the

shadows resulting in a bright airy image with the highlights burnt out. Try to find out what makes the room you are photographing unique and interpret the spaces in ways that make them desirable. See if the lighting should be soft and mellow with no hard shadows or lit brilliantly for large open spaces. Lights must be selected and placed properly to create attractive shadows or break up a flat ceiling. This is where your skill and judgement as a photographer comes into play; mood is more important than anything else.

▼ Hard, direct sunlight can prove useful, as has been the case for this shot of a conservatory, when it comes to creating attractive shadows. The shadows in this scene complement the symmetry of the design, and provide a useful way of filling what would otherwise have been a very empty foreground.

 Sinar X, 1/8sec at f/16, ISO 100

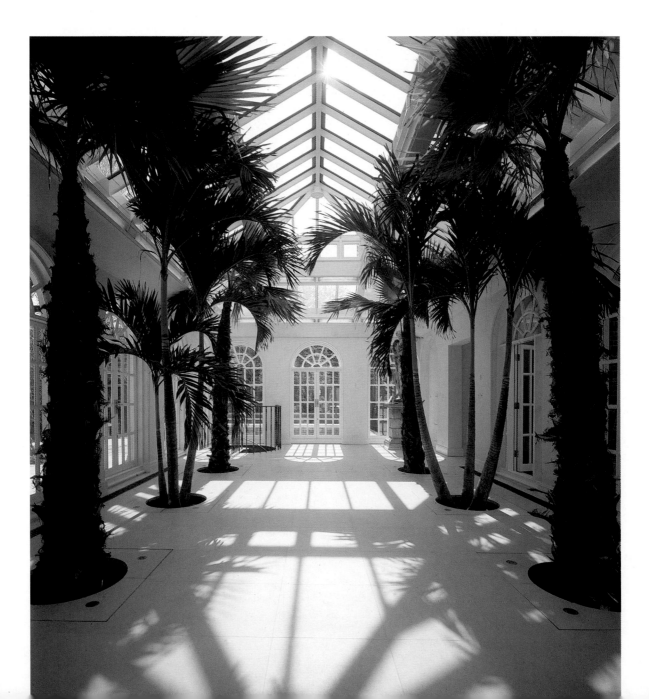

Natural light

The weather is usually not such an important aspect for interiors; however, soft diffused light from overcast skies helps in balancing the illumination inside a room and at the same time showing exterior details through the windows. Hard, bright sunshine can be difficult to contend with, although the patterns created by strong sunlight can generate dynamic interiors.

Sometimes it is better to wait for the sun to move round the building resulting in a softer light coming through into the room and bouncing off the walls and ceilings. The mood, lighting and how you perceive the final picture should be determined by forward planning and memorizing details from each room as you walk round. For many interiors the main source of light is daylight and it is natural to use daylight-balanced film, but any additional tungsten lighting within the room will show as a warmth to the colours. Low-wattage bulbs show up more yellow than high-wattage ones and may have to be filtered with a pale blue, cool-down filter, usually an 82C to counteract any excessively warm colour casts. A colour-temperature meter will give an accurate guide to the strength of correction filter to use.

Windows are an important feature for interior photographs as they give rooms a bright and airy ambience. On sunny days supplementary lighting can be added to compensate and balance the daylight, but achieving a balance between the daylight and supplementary lights can be challenging.

Although most dusk photography is taken to illustrate exteriors there are occasions where taking interiors at dusk can add that extra dimension to your picture. As with exteriors, the timing for such images is important as you want to still be able to see the general shape of the building but for it to be dark enough for the lights to create an atmosphere. Although you may have to wait to take such pictures its worth it in the long run.

Additional lighting

If you decide to set up supplementary lighting for an interior photograph, as I have mentioned before, be careful not to over light the room. It is a common fault with many interior photographs. The worst-case scenario occurs when the photographer decides to show every detail in each corner of the room and does so by adding as much extra lighting as possible, at the same trying to capture as much as possible with the widest lens available. The resulting image is flat and lifeless. In many interiors it is best to keep the illumination natural and simple by photographing the interior with the available light;

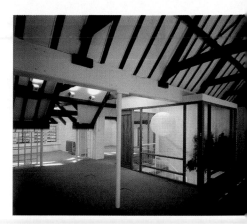

▲ **Even if you don't use supplementary lighting you can use reflectors to bounce light back into the room. This is amazingly effective, and can often give a more natural effect than using flash.**

📷 Sinar X, 4secs at f/16, ISO 100

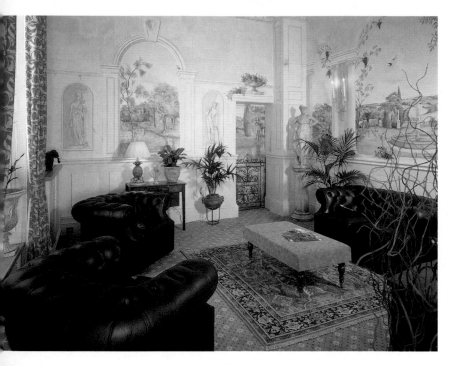

 It is vital that you do not over-light a room when you add supplementary lighting, doing so can result in it having a flat, artificial feel.

📷 Sinar X, 1sec at f/16, ISO 100

fight the temptation to swamp the room with light. Usually there is sufficient light within the room and it is surprising how just using white card as a reflector to bounce light back into shadows produces a graduation of tones from one plane to another.

When setting up your lights try and avoid placing one next to the camera or, if you have to, tone down its intensity either by reducing the light output by turning down the controls on the light unit itself or by bouncing the light off the wall behind the camera position. When umbrellas, which give a spread of soft light, or soft boxes, which concentrate the beam more so, are placed over the light source the power of the light output is diffused. By using barn doors or 'flags' it is possible to control the direction of this soft light. Such diffused light, when used as a fill-in to the main key light, softens the shadows and gives a natural feel to the room.

If possible, without them being visible in the picture, place any lights about one third of the way into the room. This creates the impression of depth in the picture, as the lightest areas are shown towards the middle and back of the room. The darker foreground acts as a frame to hold the viewer's attention in the centre of the image. Setting your key lights away from the camera position alleviates the problem of unwanted light, even with the use of baffles and barn doors, spilling onto the walls and ceiling nearest to the camera.

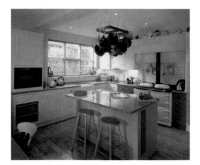

🔺 When a room is dominated by artificial light you should choose a white balance or use the filters that are appropriate to this, however, you should bear in mind that any windows allowing daylight in may appear relatively cool as shown in the image above.

📷 Toyo G, 3secs at f/22, ISO 100

Once you have decided where to place the camera in the room and composed the image in the viewfinder, carefully analyse the lighting. Is the room too big for any supplementary lighting you put in to make any difference? How many mixed lights are there in the room and what architectural features are important to record? Then decide if you are going to add extra lighting or expose the image by just using the existing lights. If necessary use a colour-temperature meter to correct the available lights or at least apply a filter for the main light source.

Small lights recessed into the ceiling in conjunction with architectural down lighters on stalks pointing up from floor level or mounted from fixed positions on the walls illuminate most modern interiors. These form an integral part of the illumination within the room, usually in combination with daylight from windows and skylights. It is important not to over-light the room using the supplementary lights as this will either make the picture appear flat and the ambience will be ruined. A flat, one-dimensionally lit architectural interior with no shadows is one of the most boring images a photographer can make.

Balancing the lighting so that the room lights and their effects are not lost during exposure takes care and precise metering. In order to show the interior lights at the same time as exposing

▲ The ideal exposure time when you are using fill-in flash is approximately 1/2sec to 2secs, this allows there to be a natural balance.

📷 Toyo G, 6secs at f/16, ISO 100

◀ In many situations it is important that the colour balance is recorded accurately. This is particularly true for those photographers that want to turn professional as accuracy is often as important as creativity.

📷 Sinar X, 1sec at f/16, ISO 64

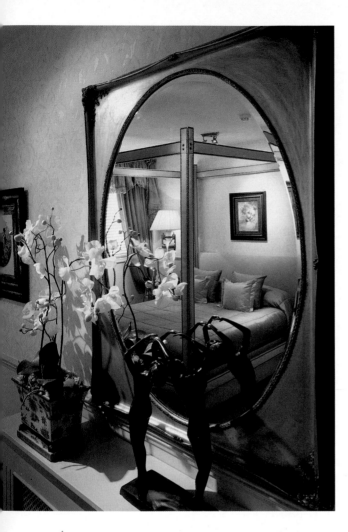

▲ Using mirrors is a fun way of adding a little life to an image. You can use them as a frame to pick out an interesting part of the interior, just remember to avoid capturing your reflection as well as that of your subject.

Sinar X, 6secs at f/16, ISO 100

for detail outside the windows, it is advisable to use a slow shutter speed but make sure the time is not too long as this may result in a colour cast, particularly on film. The ideal exposure time in conjunction with the fill-in flash is between half a second and two seconds. In situations where you have a mixture of daylight and tungsten lighting and flash is being used to balance the daylight, the combination should theoretically result in an accurate colour, but if the shutter speed is too long the ambient lights will overwhelm the daylight and flash, resulting in an unacceptable colour cast and burnt-out light sources. To compensate I add a colour-correction filter, usually an 82C or 82B, to take out some of the warmth of the tungsten lights, while still retaining the overall ambience.

The only way to be certain of accurate neutral colours on film is to test process it, this is where digital has a big advantage. Particularly with the flexibility of shooting in a raw format.

Architects, builders and interior designers sometimes employ specialist lighting designers to create exciting environments, using mixed lighting for working, living and leisure facilities. In these situations it is best to use a colour-temperature meter and filter for the overall lighting mix by standing by your camera and pointing the meter in the same direction as the camera is facing into the room. The reading should give the filtration required for the whole interior and let the secondary lights stay unaltered. Unless of course you are working for a client who wants all lights photographed as white light, with no colour casts anywhere in the picture, in which case you will have to filter each light separately and turn each one off in sequence while you are making your exposure.

Be careful: sometimes the lesser lights are deceptively strong and could impinge on the overall colour balance in the photograph if the exposure is too long. By concentrating the filtration on the main light source this creates visually interesting images and gives the feeling of depth within the picture where pools of incandescent lighting add shape to what otherwise could have been a lifeless room.

Case notes 14

Mixed lighting with fluorescent, daylight and tungsten can prove a problem, especially if one source is brighter than others and would dominate the exposure. In this image I had to include the bar area, which was lit by tungsten lights; the lounge area was lit by fluorescent lights recessed into the ceiling and daylight lit the gymnasium and stair on the right. The daylight was the main illumination but it was not strong enough to reach the lounge on the left. This meant that if I exposed the picture just using the available light the left-hand side of the image would become unacceptably green. Using the colour temperature meter I calculated I needed a 10 magenta filter to take some of the green of the fluorescent lights and during the 12-second exposure I had an assistant turn them off after 3 seconds. Two flash units with softboxes were positioned to fill in the bar area to counteract the warm colour cast given off by the tungsten lights above the bar. I also added an 82A colour-correction filter to help knock back some of the colour cast from the tungsten lights as the exposure was such a long one. The timings and filtration was calculated using instant-print film. Apart from the excessively blurred image on the television screen because of the long exposure, I think the technique worked.

📷 Toyo G, 12secs at f/22, ISO 100

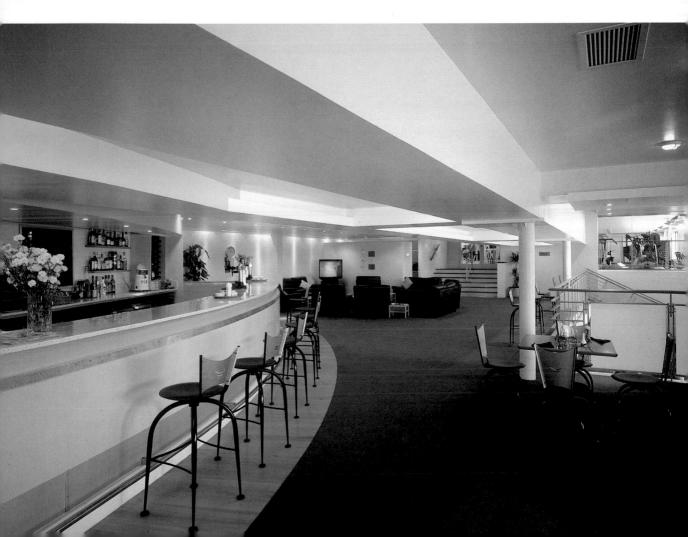

◀ **This winebar in Cardiff, Wales, UK, is dominated by a large central light, and this meant that it had to be balanced by several supplementary flash units to provide more even lighting.**

📷 Sinar X, 5secs at f/22, ISO 100

In some interiors with a mixture of incandescent light sources they are all connected to different electrical circuits and can be switched on and off independently. This gives the photographer the advantage of controlling the intensity each light gives to the shot either by turning it down or off during the exposure. It can be a tedious procedure to identify which switch operates which light and working out the exposure time but the difference between some light sources can be quite surprising and the instant-print film or a digital camera is excellent for working out the various exposure times necessary.

As I have mentioned previously, room interiors, even with supplementary lighting, can appear flat and look like furniture showrooms. One way of creating the extra dimension of depth in what is basically a simple room is to use any mirrors available and construct the picture so that the mirror becomes part of the composition. In other words, a frame within a frame makes a more interesting image.

Large open public interiors are often easier to photograph than smaller ones. Usually, such spaces are too big to light artificially and careful measurement of the existing lights using a colour-temperature meter, or adjustment of the white balance either on camera or, when shooting raw files, on computer will have to suffice. Some spaces are lit by many lights that are principally functional, although there may be some decorative lighting, and the exposure and colour-temperature measurements should be made from the dominant light source so that the area as a whole appears natural.

Most large public interiors, such as museums and railway stations, are predominately lit by daylight flooding from large areas of glass and thus making it easy to filter. I find that by just placing a magenta filter over the lens is enough to correct for any slight green colour cast resulting from toughened safety glass. Again, the auto white balance function of a digital camera will normally give the right result, but it should not be relied on and you should input the required white balance yourself.

In such large open interiors people tend to add scale and it can be a nice touch to use a slightly longer shutter speed to blur their movement showing them interacting within their environment.

Props

For most interior photography it is useful to carry a selection of props. If you have the luxury of an initial visit, at least the decision whether to prop the room can be formulated before starting the shoot. It is useful to carry a selection of magazines, books and flowers just in case you need something to add to your picture. Working with an interior designer makes life a lot easier as they usually carry a comprehensive selection of props and they rarely arrive at a shoot without already reconnoitring the site and discussing the day's photography with their client beforehand. Props and their use in dressing an interior can prove to be a sensitive subject, as tastes can vary enormously

Case notes **15**

Small intimate interiors can be particularly challenging to photograph, especially when they are lit by mixed lighting. For this photograph I used two flash units with soft boxes as diffusers to light the area nearest the camera, but I set the output from these units to half power so they would only fill in the detail on the kitchen units. The main light came from the window and after measuring the supplementary tungsten lights with the colour-temperature meter, I used an 82C pale blue filter to take out some of the yellow colour cast in the picture; it was important to show the correct colour of the kitchen units and I also placed a small light between them to separate them in the frame. As well as the units themselves it was important to capture the detail within the glass display unit so I used a long exposure with the fill-in flash only set at half power.

Sinar X, 1sec at f/22, ISO 100

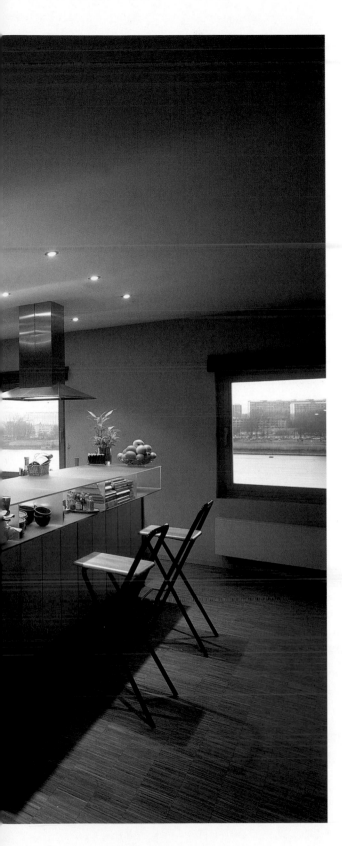

◀ ▼ These are two of a typical set of Interiors showing different aspects of an apartment in Antwerp. The architects are Poponcini and Lootens based in Antwerp, specializing in residential complexes mainly in Belgium and Europe. The photographs had to illustrate the open plan design features of this luxury apartment and incorporate the views of the river Schelde on one side and the Cathedral on the other. I waited until the light outside was fairly weak at end of the day and used tungsten film without any extra supplementary lighting to make my exposures. By balancing the adequate daylight with the interior incandescent lighting I did not loose any of the ambience within the room or any detail outside the windows. The blue cast outside the window makes the interior appear warm and inviting. The two detail shots of the staircase were exposed using daylight film showing the room was designed to let in pools of light from the skylights in the roof.

📷 Left: Sinar X, 6secs at f/22, ISO 100
Below: Sinar X, 2secs at f/16, ISO 100

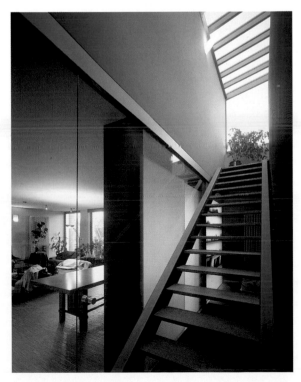

between the client, the interior designer and you. Sometimes a bit of tact and diplomacy will come in handy. Most of the time what props to take on a shoot depends on the subject. If I'm photographing a kitchen then I'll take a selection of fruit, bread, magazines, cookery books, vases, flowers and a couple of wine bottles. Normally you would assume the kitchen being photographed is already equipped with all the right accoutrements but it is wise never to take anything for granted. My imperishable props, which I use on location are stored in a box and left in my vehicle. Over the years I have collected a variety of useful crockery pieces and fabrics for use as props, should I ever need them.

Flowers are the standard prop for most interiors, but adding flowers can be overdone and the wrong sort could spoil the look of a room entirely. Keep the flowers as simple as possible and use them sparingly, either to add a touch of colour or to hide the camera's reflection in a mirror.

Most modern buildings have displays of potted trees or shrubs dotted around the room or used as space dividers between workstations. These can be useful to break up large areas of blank walls similar to those found in receptions and if they do appear in your photograph make sure all the dead or dying leaves are removed and cleared away. Large internal foliage can become a problem if they are too tall and block off sections of the room but normally plants are decorative and useful in breaking up blank walls and hiding unattractive features.

Most fireplaces look dead and uninteresting in interiors and a quick and simple way to create an instant fire is to tightly roll up newspapers and set a match to them just as you are ready to make your exposure, obviously taking due care. Timing is important as newspapers tend to flare up quickly, but you need to leave enough time for the flames to catch hold or pieces of the unburnt newspaper will be seen in your picture.

▲ **Most large public interiors are lit by daylight coming through large areas of toughened glass, this is normally tinted slightly green so the colour of the light should be corrected by placing a magenta filter over the lens.**

📷 Toyo G, 2secs at f/16, ISO 100

▶ **A contre-jour, against-the-light photograph of an interior, which required supplementary lights, a studio flash unit with a softbox angled from the right to illuminate the shadows, carefully placed to reveal the detail in the fabrics and furniture but turned down to half power so as not to spoil the backlighting affect.**

📷 Sinar X, 1sec at f/16, ISO 100

◀ **Adding flowers can really bring life to an image, making a room look 'lived-in' and adding a splash of colour to lift your composition**

📷 Toyo G, 1sec at f/16, ISO 100

⊕ TRADE SECRETS

Sensitive subjects

When taking photographs in cathedrals, churches or any place of worship it is important to ask permission before setting up a tripod and using your camera. Try and be discreet, turn off your flash and set your camera to silent if possible. Sometimes you may be asked to pay a small fee or make a donation before being allowed to take any photographs.

Architectural details

Most photographs are taken at eye level as we tend to accept our environment as normal at this viewpoint. For something more interesting and to add some variety to your images try varying your field of view and see how even more mundane situations can dramatically change by turning your head and looking at what is directly above you or by shooting down from higher vantage points. Interior details, especially in churches and other historical buildings, provide plentiful opportunities with their domes, and shooting from unusual angles can visually enhance arches and other architectural features.

▲ Architectural details, whether large or small, are a great way of making creative images. You are freed from the constraints of capturing the whole building and are able to concentrate on photographing individual shapes, textures and patterns.

 Mamiya RZ67, 1/60sec at f/11, ISO 400

Detailed images shown from various vantage points or even more directly by focusing on relevant architectural features such as patterns, shapes and unusual details can become simple graphic elements, which are visually strong in their own right. If you are putting together a portfolio then these are a vital element to add colour to the main sequence of shots.

Any building's exterior or interior will, by virtue of its shape and construction, determine whether the images of details are portrait or landscape format. These images usually complement the main photographs but do allow you more freedom and a certain degree of creativity. However, it is important to vary the composition and style of detail shots to add an abstract feel and visual impact to the overall shoot.

I tend to shoot all my key images – those which are going to become front covers, full-page illustrations or exhibition prints – on the large-format camera but all architectural details I shoot digitally. These digital images should represent a certain creative style to the overall quality of the shoot, especially when shot from oblique or unusual angles. Typically these could be details of doorways, lintels, light fittings, staircases, windows or important construction features.

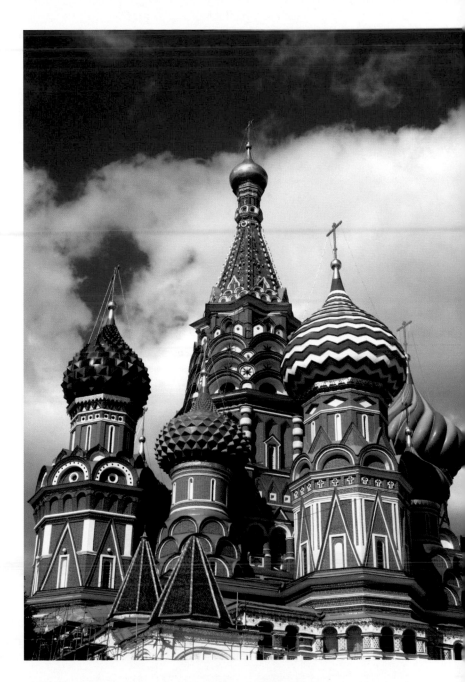

▲ At the time that this photo was taken St Basil's Cathedral in Red Square, Moscow, Russia, was under refurbishment and the bottom half of the building was surrounded by scaffolding, but this detail showing just the top half was enough to illustrate this recognizable building.

EOS 1Ds, 1/100sec at f/11, ISO 200

Case notes **16**

Nutfield Priory Hotel is situated just south of London and I was finding it difficult to come up with an interesting shot of the foyer. Realizing that the ceiling detail was an important architectural feature, I decided to incorporate it in the photograph as well as showing the reception desk. I set my camera up in the minstrels' gallery and lit the ceiling with large flash units and placed similar lights in the corridor and underneath the gallery to show the reception area. The exposure was determined by measuring the daylight coming through the main windows and then balancing the light given off by the flash units. I used a 5x4in large-format camera with a 75mm wideangle lens and was careful any camera movements did not exaggerate the slight distortion of the image, which is still visible at the bottom of the picture.

📷 Toyo G, 4secs at f/22, ISO 100

Case notes **17**

Photography of architectural models is a discipline in itself and can present an interesting challenge to a photographer. Photographs of scale models or larger projects have to give some illusion of reality and the key element is lighting. I tend to use one spotlight to create the directional effect of the sun and pieces of white card or mirrors to fill in the shadow areas, and to bounce shafts of light back into the small windows.

The camera has to be almost level with the base of the model to give the correct perspective and a dark background heightens the drama of the model, especially if there is a lot of detail on the building.

📷 Sinar X, 1/2sec at f/22, ISO 100

These details are usually important features, both inside and out, complementing the overall design of the building and its location. While most architectural shots are pin sharp and without converging verticals or other apparent flaws, there are occasions when details can be augmented by emphasizing the visual impact of converging verticals, out-of-focus backgrounds and other dramatic effects.

One way of getting the best from an abstract of a modern building is to combine converging verticals with a blue sky. Try standing close to the building and pointing the camera upwards with a wideangle lens to create an exaggerated perspective. You also have more freedom to experiment with composition so try moving the camera as you look through your viewfinder.

◀ **Capturing details doesn't necessarily mean excluding the rest of the building. This statue outside an EU building in Brussels, Belgium, acts as a good centrepoint to the image, while the receding lines of the façade act as an attractive background.**

🄾 Sinar X, 1/30sec at f/22, ISO 100

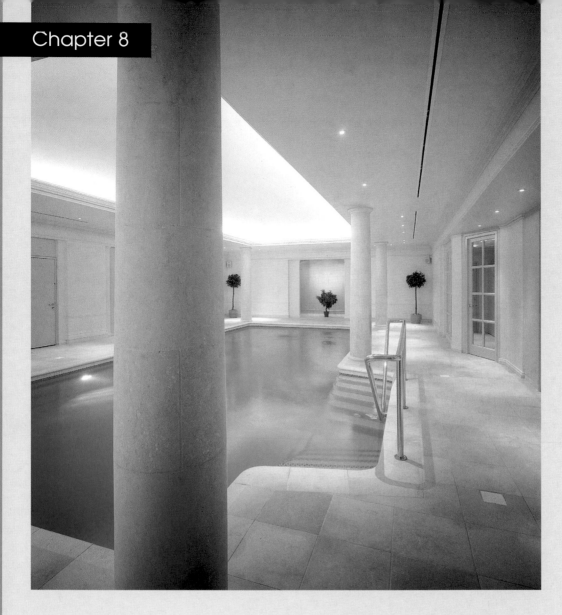

Using artificial light

While many photographers rely on ambient light, that from existing light sources, sooner or later it will become necessary to add some artificial light to the scene. This is available in various forms from the most basic of built-in camera flash guns to full-blown portable studio lighting with various attachments. As ever, the right equipment is useful, but it is what you do with it that counts, and this chapter aims to show you how to get the best from artificial light.

▲ When you are faced with mixed lighting, as is the case in this leisure pool, you can use supplementary flash units to suppress any unwanted colour casts that may occur.

Sinar X, 8secs at f/22, ISO 100

Balancing light

Most architectural photography is created using existing light, either daylight or artificial light, which in many circumstances is then corrected by filters or by using the white balance of a digital camera. However, because the nature of an architectural photograph is in large part dependent on the quality and intensity of light it can be necessary to supplement the available light.

All light has a dominant direction that sets the ambience and this is called the key light. Daylight entering a room illuminates specific areas and leaves the rest in comparative shadow. Such light enables you to show realism and atmosphere, but there times when supplementary lighting is necessary to either soften the daylight or accentuate and balance the available light within the room. Daylight coming through windows, doors or skylights can either be strong direct sunlight or soft diffused light such as on cloudy days. If the room already has some weak artificial lighting the long exposures necessary to record detail in the shadow areas not illuminated by the sunlight can result in uneven and overly contrasty images, as the long exposure can result in even the weakest light badly overexposing. This is where additional lighting is added to balance the light levels. Supplementary lighting can be bounced from walls, ceilings or existing light fixtures and helps the eye to separate each element of the room from the others. Control of supplementary lighting should mimic nature, as artificial light should not appear synthetic but relate to the mood of the subject.

I once met an Italian photographer who specialized in interiors; I was very surprised when she said she envied me working in Britain because of the predominately softer northern sunlight compared to the harsh Mediterranean light she has to contend with in Rome. She was equally surprised when I told her I was jealous of her working in Italy with more or less constant blue skies and warm sunshine for approximately nine months of the year. It goes to show that the grass is always greener somewhere else!

The human eye will accept a greater contrast range in light and shade than film or a digital sensor and can pick out detail in strong highlights or deep shadows. This is why, in order to retain detail in both highlights and shadows, it can be essential to add extra lighting.

The most common fault when using flash is to place the main unit near the camera, resulting in a heavily lit area immediately in the foreground giving an artificial feel to the room. This is more of an issue with on-camera flash as it is harder to correct for, but with studio lights you should aim them approximately one third of the way into the picture area. If you need to 'fill in' the immediate foreground then either turn the light output from the flash unit down or swivel it to face the wall behind the camera. This gives the picture a feeling of depth as the lighter area appears in the middle distance and the foreground acts as a frame.

What to use

The most commonly used artificial light is the built-in flash; however, this is generally very weak and inflexible. Hotshoe-mounted external flash units are better, and if you are buying one of these then you should definitely get one that allows you to tilt or swivel the head as this will give you more control. You should also consider buying an off-camera flash cord to give you even more flexibility.

However, even sophisticated on-camera flash units are limited and the more serious photographers may want to consider investing in a portable studio lighting system. These allow you far greater versatility and mean that you are able to alter the quality of the light, softening it either by reflection or diffusion. Flash or strobe units are calibrated to provide

the same colour of light as daylight and as such are useful for filling in the shadows caused by daylight.

Portable flash units have adjustable controls allowing you to alter the strength of light from the unit and fall-off in flash illumination while balancing the counter-light you are adding with the existing ambient light. These units come with attachments such as: soft boxes, umbrellas, reflectors and barn doors, which attach to the sides of the light so that the direction or 'spill' of the light can be controlled or diffused as necessary.

The majority of room interior lighting is sufficient, with filtration, for photography and in most modern buildings lighting engineers and designers have been commissioned to create the ambient lighting so it doesn't make sense to add so much extra lighting that it will kill the mood.

Case notes **18**

The two hotel staff changing the bed in this picture help create an atmosphere of freshness as well as adding scale to the room. I placed a studio flash unit with a soft box just inside the doorway of the bathroom so it would light the chambermaids and create the dimension of depth by pulling the viewer's attention down to the back of the room.

A mild soft-focus filter was used to help tone down the lights and create a glow in the room. Normally people can date pictures very quickly but the staff uniform is timeless so these images for the Royal Crescent Hotel in Bath should have a long shelf-life.

📷 Sinar X, 4secs at f/16, ISO 100

However, there are some occasions where artificial tungsten light can be used to fill in the existing tungsten lights. Tungsten lights have a colour temperature of between 3,200K and 3,400K and are extremely useful for use in long exposures, particularly as they can be used to show precisely the quality of the light and where the shadows are going to fall. These lights are adjustable and come with removable Fresnel lenses that can give concentrated beams or a wide spread of a more diffused light. One big advantage they have over the larger flash units is that they are portable and lighter to carry, thus giving more options for a wide variety of situations.

▲ **When you need to fill-in the foreground you should take care not to overlight it. Making sure that the middle of the image is slightly lighter than the foreground, by dimming the foreground lights, will help to give the image a feeling of depth.**

📷 Toyo G, 2secs at f/16, ISO 64

Reflection and diffusion

The trick in most shots is not to over light the interior with too much supplementary flash. Harsh, uncontrolled flash lighting forms hard shadows and can spoil the ambience of the interior you are photographing, and the control of the mixed flash and ambient lights is critical.

Most artificial light sources require softening in some way so that the light does not cast overly harsh shadows and give the shot an artificial appearance. This is true for both full-blown flash units and compact hotshoe-mounted ones. The two main ways of softening the burst of flash to make it appear more natural are to reflect it from a surface or to pass it through a diffuser. Reflected light reaches the subject via a reflecting surface and the quality of this surface and its distance from the light source and the subject will determine its effect. This is one of the reasons why even a basic hotshoe-mounted flash is a

lot more useful than the built-in flash that many cameras offer, as you can tilt and swivel the head to bounce it off walls or ceilings. You should be careful, however, as the burst of flash can pick up the colour of the surface from which it is reflected, adding an unwanted cast to your subject. Diffusers are equally useful, and available in a number of different forms ranging from a simple slide-on diffuser for a hotshoe-mounted flash to soft boxes and umbrellas.

Reflectors used with flash units or tungsten lights give a concentrated light source for specific effects. They offer a creative edge to your lighting and can be used to create a harder light or act as a substitute for the sun in room-set photography. If they are not carefully controlled the light can give very harsh shadows and spoil the effect you are trying to create; however, used in conjunction with coloured gels they can generate some very strong graphic images.

Balancing the amount of flash with the available light comes with practice and requires patience, time and a lot of trial exposures, but with skill the final result can give the impression that no supplementary light has been used at all.

◀ **Reflectors offer you something different for the creative side of your photography. The amount of control that you can exert over the light is incredible, used here they help balance the existing light, and when combined with coloured gels they can create some striking images.**

📷 Horseman, 4secs at f/16, ISO 64

Sinar X, 3secs at f/16, ISO 100

Case notes **19**

Older historical buildings can often be difficult to photograph. The windows are usually smaller than those in modern office buildings and the amount of daylight coming through them can rarely be relied upon as the main source of light for your exposures. Because of this I added a lot of supplementary flash lighting to photograph this library in Winchester College, UK, especially in the roof area, as the whole room had been refurbished and I wanted to pick out the roof timbers. I composed the picture with the stairs in the foreground and used the small statue on the right as a frame to keep the viewer's attention in the centre of the image.

Toyo G, 5secs at f/22, ISO 64

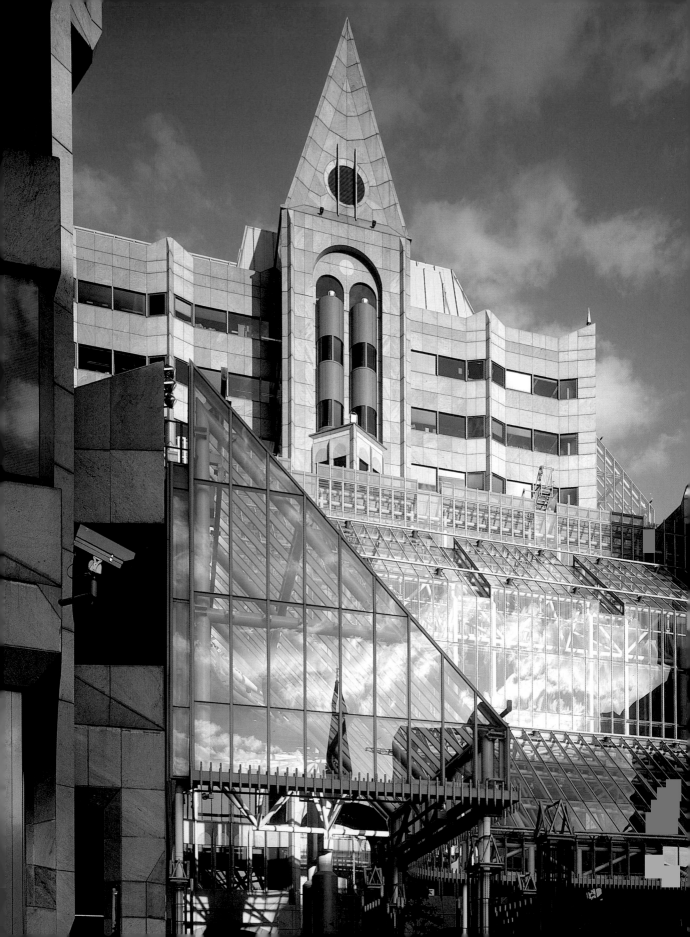

Turning Pictures into Profit

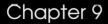

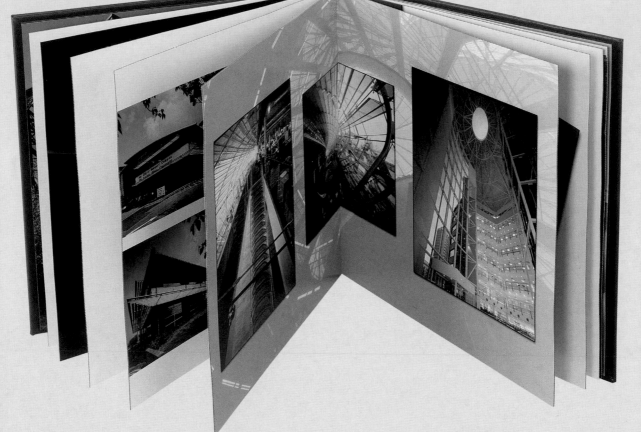

Portfolio courtesy of Glorious Books

Building a portfolio

The most effective way of promoting your business is to put together a portfolio, either on a website or in a display book showing a wide range of your images, either from commissioned assignments or personal work. A good portfolio is your calling card to success and where your own style should become obvious. Aim your presentation at your target market; it is important for potential clients to have a clear idea of your strengths and creativity when they view your work. It is essential to know which pictures to use and how to use them, so they make the strongest possible statement about your work.

▲ Regardless of whether or not you want to make money out of your photography, creating a portfolio gives your images a great deal more impact than simply presenting them in a piecemeal fashion.

Marketing your work

You need to decide what kind of photography you would like to concentrate on and what is going to be your target market. When putting a portfolio together make sure the work you are showing is the visually strongest you have taken; be ruthless in choosing your samples and make sure they illustrate a good range, both technically and visually.

What do you show as your portfolio? Some people prefer to see samples of original work such as transparencies or prints and the presentation of these samples is important. Make sure they are fresh and not dog-eared, as these portfolios are the window to your work.

▼ It is crucial that you only show your best work as part of your portfolio. Don't include any shots that you think weaken the selection, just to show more diversity.

Print the best images onto promotional cards and mail them out to selected buyers or upload them onto your website and the site to potential customers. Remember when you mail out any information to follow it up with a phone call a few days later. Make sure you speak to the person within the company that you have already identified as the buyer of photography.

It is pointless and expensive sending out numerous portfolio information cards in the hope that one might strike lucky, whereas a carefully targeted mailing will prove a more efficient and cost-effective method of finding new clients. So consider carefully who will have a use for your photography.

The main advantage of a website is that the images can be updated at regular intervals and act as an electronic brochure, where a potential buyer can view samples of your work almost immediately on screen and have some idea of your style. If they are interested enough after seeing the website to contact you to make an appointment then show them samples of original photographs, published work or a portfolio book; better still, if practical, leave your portfolio book with

them, offering to collect it a later date and at their convenience. Such a portfolio book is going to be more beneficial in the hands of a potential new client than sitting in draw in your office. However, the cost of producing a book can be prohibitive so make sure you are comfortable with leaving it with a stranger.

The more you advertize your site the better, whether you use it for selling online, putting out information about yourself or sending out press releases, it all means more exposure for your work and hopefully potential sales. Push your website as hard as possible, with every piece of information about yourself having the address attached, from your email signature to the stickers on your transparency sleeves, along with your other contact details of course.

At least once a year, or preferably quarterly you should remind past, present and potential customers of your work by inviting them via email, post or telephone to view your most recent images on the site. At the same time take the opportunity to inform them of any assignments, exhibitions, seminars or awards you have achieved during the year. It all helps to keep your profile and name at the front of their minds when the look for a photographer.

Case notes **20**

The spiral staircase dominated the atrium of this modern office building, the architect was particularly keen to show it in his brochure. However, when I set the camera and looked through the viewfinder, the picture seemed to be lacking something. As I was looking at the composition on the ground-glass screen the two men walked into the frame and straight away the composition looked right, as they

gave the image scale. I asked them to talk to each other on the landing where I had first spotted them and to my delight they adopted these relaxed and natural postures as if the camera wasn't there at all. It goes to show you sometimes need that little bit of luck.

Sinar X, 2secs at f/16, ISO 100

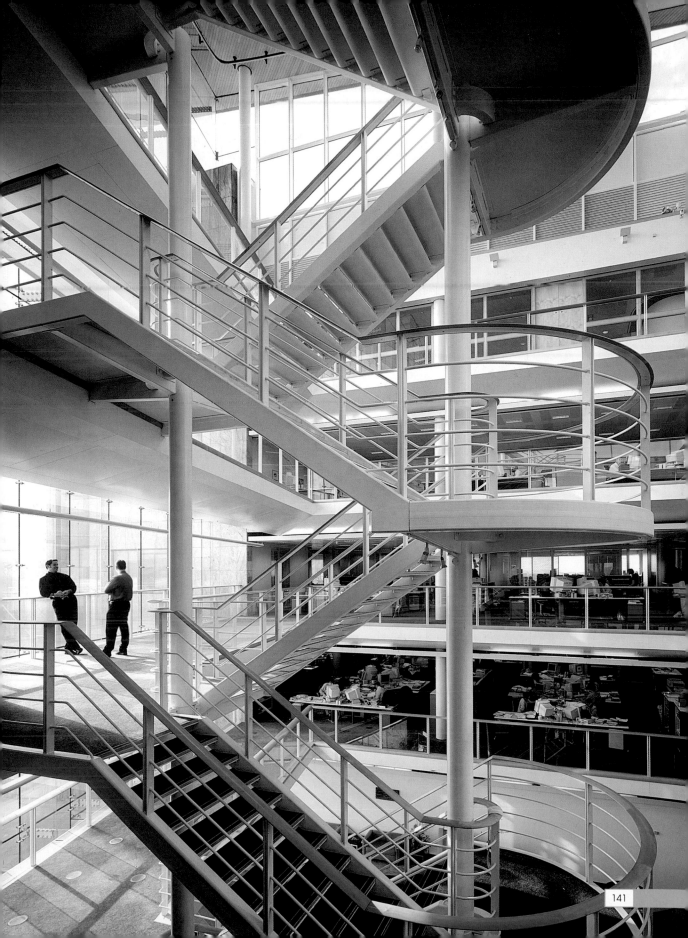

Most importantly of all, give your clients a reason to return, such as weekly updates or to view a 'what's new' section on the website. As a rule put fewer pictures on your site but update them more often. This gives you an excuse to contact your clients at regular intervals to see if they have visited your site recently or to ask their permission to use a picture you had recently taken for them on your site.

Reciprocal links are an important tool to help to boost the number of search engine hits that you receive so always ask clients that have use your photography to post a link on their website.

Other forms of marketing that are particularly worth considering are industrial trade shows, specialist journals and trade publications. The value of specialist architectural journals is in the fact that you are reaching the very target market you want to view your work and how much you spend on advertizing obviously depends on your budget. Adverts can be expensive and one way to avoid these fees is to submit a piece of news about your business complete with photographs. Contact the editor first and find out what the readers like to see in their journal. In editorial work you can still specialize in one area of architectural photography, such as interiors, but a varied portfolio will bring in more clients.

It is extremely important to plan carefully and analyze which is the most cost-effective method to promote your business. Any sort of feedback will help you tailor your marketing to the needs of your clients and save you time in the future. Keep a record of each new contact and ask where they heard of you and what attracted them to contact you in the first place. That will help you to find out which is the best marketing avenue.

In an ideal world the best way of achieving work is by word-of-mouth recommendations and this will eventually happen, either in the short term or long term but the most difficult part is getting established and having your work recognized by buyers of photography.

There is no easy answer; accept that you will to try some of the methods mentioned above, as well as the hardest of all: cold calling. This is where a lot of groundwork before you make contact will pay off. Subscribe to the relevant trade journals, architectural magazines and even walk round the periphery of building sites and write down any details of the companies you think it might be worth approaching for photographic work. Their business addresses and contact details are usually displayed on the hoardings surrounding the construction site. Make a target list and if possible find out any relevant email addresses and start working through them by identifying

the correct person to contact. It is worth remembering that the company may already be using another photographer but ask to leave your contact details just in case the occasion arises that they need to use another photographer for whatever reason. Many companies now do their own photography, using easy-to-use digital cameras and the most frequent comment I hear is: 'It's not as good as you can do but it'll do for our limited needs.' I usually answer such a statement with, 'OK! But if you ever need high-quality photographs for your annual report, important exhibition or want to enter some images for an architectural award then please contact me.'

Most of the time you will face rejection but with persistence you should be lucky and your business should start to grow.

Specializations

When you have the basis of a business it may pay to consider specializing. Identify the type of architectural photography you would like to specialize in, such as interiors, then contact as many people as possible, in this case interior designers, fabric manufacturers, kitchen companies and anyone else who might be interested in seeing samples of your work. This is known as target marketing and you should research your potential client thoroughly before making an approach.

If, however, you prefer to undertake all aspects of architectural photography, encompassing exteriors and interiors, then you can be more general in your approach, so try contacting architects, builders and construction companies, as they would be more likely to commission someone who is confident enough to handle all the problems on such a broad assignment.

It pays to do your homework before you consider taking architectural photographs, as this will give you a clear idea of the important things to shoot and enable you to decide which images are relevant to your potential

customer and this will dictate how you should approach them for the first time. This should prevent the embarrassment of you arriving at an appointment to discuss your work with a prospective client with the wrong sort of pictures in your presentation portfolio.

When talking to potential clients it is useful to receive feedback on the images in your portfolio, particularly if you are not successful in achieving a commission, as it will help you to weed the weaker pictures from the stronger ones for the next interview. Remember that most of these potential clients will either be using a photographer on a regular basis or a selection of specialist photographers to cover their requirements and it is going to be very difficult to persuade them to take a chance on you, but by listening to their feedback you should improve your chances no end.

You need a bit of luck to get started, but you can make your own luck. Put some effort in getting your name recognized by the buyers of photography. Whatever marketing route you take – ideally it should be a mixture of them – whether it is expensive adverts in trade journals, editorial pieces about exciting projects you have completed or news of something special you have achieved such as winning a photographic award, you should concentrate on keeping your potential customers awareness of you high. All publicity helps in building up your reputation, particularly if you are specializing your work.

Think about your objectives for your portfolio and what markets you want to target. Ask yourself whether you want more business of the kind you are already doing or whether you are interested in trying something different. It will pay you to constantly look at the saleability of your work and ask yourself, 'Are these images likely to influence the clients I'm aiming for?' If not then cull what you have and refresh your portfolio with new styles.

Once the break comes your way it is up to you not to let your new client down and to be professional in your business manner and quality of images.

Business skills

Most photographers at some point want to make some money out of their passion. Whether this is as a full-time professional architectural photographer or as a part-time amateur looking for a little extra income; the skills required are largely the same. Being able to market yourself and being able to deal with prospective and actual clients is crucial if you want to be able to turn your pictures into profit.

▲ This modern office building across the River Moscva from Red Square, Moscow, Russia reflects the colourful domes of St Basil's Cathedral.

📷 EOS 1Ds, 1/1000sec at f/16, ISO 100

What to charge

Most photographers charge on a time and materials basis. Their time is calculated on an hourly, half- or full-day rate depending on location, the number of photographs exposed and complexity of the assignment. Material, processing and post-production costs are included in the final estimate. It is difficult to determine the costs for a job precisely and give an exact quote, especially when there are variables such as weather or other site contractors causing delays. There are also times when it is not possible to carry out a preliminary visit to reconnoitre the site, leaving you to rely on secondhand information to estimate what the assignment is going to cost.

You also have to make it clear to your client what constitutes a full day and confirm before you start that your chargeable time starts either once you're on site or when you leave your studio. Decide whether to charge travelling time to and from the location or a set fee per mile. Alternatively, decide what percentage it should be in proportion to the full-day rate. Typically it may take you three hours to arrive on location, four hours to complete the assignment and three hours back, so some photographers charge approximately half their hourly fee for each hour spent travelling.

With a job such as photography the working day is incredibly varied; at certain times of the year this could mean waiting around for the right light and this could stretch a standard eight-hour day into a ten-hour one. The question you have to answer is whether you include the extra time in the invoice or just charge for a full day. In these circumstances you will have to come some arrangement with your client. In most instances they like to know in advance how much the job is going to cost before the go ahead is given, even if it is a ball-park figure. Unless you have a very tight and precise brief where each shot is laid out in detail it is going to be difficult to estimate the exact costs and a certain degree of flexibility on both your part and that of the client has to be incorporated into any quotes. Many times when I've been on site the client has spotted something extra, which is added to the original list of photographs and the cost of the extra pictures or additional work is included in the overall invoice. So long as you point out why the invoice is more than originally quoted and who authorized the extra expenditure there are very rarely any problems.

The clients are relying on your photographer's eye and trust your understanding of the purpose for the assignment. This is why they are paying you so don't be shy of discussing how you can best meet their requirements. There have been occasions I have spotted new angles or noticed how the light can dramatically change the mood of a building during a shoot and instinctively know a stunning photograph would be missed if I did not capture it. As a result I tend to shoot the picture working on the premise, it is better to have the shot 'in the can' and charge for it if the client likes it than not to have it at all.

Make sure your client is happy to rely on your judgement to choose the right angles, compose the picture, select the appropriate lighting and if necessary come up with 'the' image. You should also explain to clients just how long it takes to make a photograph, bearing in mind that when it is generally possible to photograph fewer interiors, as they require more setting up, lighting and filtration, during a days work than exterior shots.

Resist the temptation to under quote, especially if you would really love to shoot a particularly interesting building to add the images to your portfolio. This could become a problem if your quote is accepted, as it will set a precedent with your charges for any future assignments.

Your daily rate should be based on the factors discussed above, although it can vary slightly with experience and location. It is a good idea to know the minimum profit level

you can achieve and always stay above it for any quotes, even when using it as a price guide. It is wise to be flexible and open to negotiation without dropping below your minimum level as there will be times when you will be asked to quote for larger projects instead of individual buildings. I have been asked for a quote to photograph 14 buildings throughout the country involving days of travelling and supply 10 to 15 images at each site. Quoting for projects of this size involves a lot more thought.

⊕ TRADE SECRETS

Copyright issues

The author of any image owns the copyright to that image, unless they have entered into a written agreement with the client. Although an oral agreement can be considered as binding, assignment of copyright should be in writing. Moral rights, though remain with the author no matter what happens to the copyright.

Copyright lasts for 70 years after the end of the year of the photographer's death and offers protection against unauthorized reproduction of the photograph and entitles the owner to economic benefit from it. In practice, clients may only use images taken by the photographer in ways that have been agreed at the time that they were commissioned. If the client wants to use them again then permission must be sought from the copyright holder and additional fees negotiated. Copyright can be assigned to a third party, but only if the photographer agrees.

Travel and overnight expenses are a key factor in the costs of larger assignments. When you are travelling long distances you should allow for the weather being poor on the day you have allocated for photography in the furthest reaches of the assignment. Although it makes sense to watch the weather forecasts closely and plan your trip accordingly, these forecasts may not be as accurate as you expect. I once spent four days in Berlin waiting for the rain to stop even though the weather forecast had promised me three days of sunshine, and it is wise to allow extra time for any unforeseen problems occurring whilst you are on site or ones that occur before you arrive on location.

Typical problems I have experienced arriving on site have been a digger severing the main electricity cable, the new plumbing springing a leak causing the ceiling to collapse, the carpets not being fitted properly and the furniture not being delivered. All these issues even though on each occasion I had telephoned ahead to make sure everything was ready for photography! There is never a cast-iron guarantee that nothing will go wrong either before you arrive or whilst you are site. If you have given a set fee for the assignment then you will probably have to bear the extra costs, particularly if they are delays, but if you have a rolling contract then it is important to contact your client as soon as you know of any problems and discuss any new charges with them straight away, even if it is just your expenses. By its very nature architectural photography has a very large element of unpredictability owing to factors that are beyond your control.

Many photographers are now capturing their images digitally and face a considerable investment in digital equipment, not only initially but also approximately every three years in order to stay on top of the latest developments in cameras, software and computers. It is important to build in contingencies for the short-term future and to cover those ongoing costs in your invoice and still be profitable.

When discussing your charges for digital photography it is worth pointing out that the costs are mainly in post-production, which is intensive and time consuming. Remind your clients that all these added services are for their convenience and should reduce their own production costs; it's the old adage 'time is money' and you're saving them a lot of post-production time. It is a good idea to show the client how your charges for digital work are calculated (see box below) emphasizing that they require considerable time and effort on your part in addition to the usual assignment costs such as time and travelling expenses.

Sometimes it is worth trying to find out what sort of budget has been allocated for the project and calculating your fees accordingly. It is not often that the client divulges the exact budget, but if you can find out make sure you are happy with your price as what you invoice for the initial assignment will set a precedent for any future work with the same client.

Last-minute cancellation fees are a necessary part of a photographer's business. It is good practice to emphasize cancellation fees in your terms of business before accepting a photographic assignment. It is up to each photographer to decide how much notice is required before charging this fee, depending on how much time and effort you have incurred arranging the shoot. During busy periods it is not unreasonable to implement last-minute cancellation charges bearing in mind you could lose not only the fee for the cancelled project but also the fees for work you have turned away having agreed to undertake the original assignment. Some photographers may not charge in such circumstances, especially if they have a good working relationship with the client and the reasons for the cancellation are valid, but most will charge if given only 24 hours' notice or less.

You may also want to consider charging a percentage up front, especially if you incur some expenses prior to the shoot.

As a general rule when quoting you should be sympathetic to your clients' requirements and emphasize that you are looking to provide them with the best value you can, but do not undermine your business by undercharging.

TRADE SECRETS

Calculating costs

A combination of the following:
- Your usual creative fee.
- An overall digital production charge.
- A per-unit digital capture charge.
- Production equipment.
- Image conversion charge.
- Photoshopping or retouching charge.
- Inkjet contact sheets.
- Reference prints.
- Burning images onto disk.

Holder Mathias architects

The client and the brief

While we have already covered dealing with clients in the previous chapter, there is a great deal more to be said. Making sure that you communicate effectively with a client will mean that you understand their requirements and they understand your capabilities. This should help smooth any problems that may occur on the shoot itself and should ensure that the end product meets their needs. This should mean repeat business as well as recommendations for you.

▲ It is important to be clear about the requirements of your clients. Meeting them in person and discussing what they want from a shoot, perhaps with the aid of diagrams, illustrations and even models, will help to ensure that you meet their demands.

Who uses architectural photography?

There are many markets for architectural photography including both commissioned and uncommissioned work. There are many general picture libraries, specialized picture libraries, builders, architects and other potential clients all on the look out for great images, hopefully ones that you can supply.

Picture libraries

Specialized libraries are difficult to get into, as they only concentrate on high-quality photography and rarely accept anything smaller than 5x4In transparencies or very high-resolution digital images, it is unlikely that amateurs will be equipped with the kit to supply these. However, they can be a lucrative source of income if you are successful in getting onto their books.

For most freelance photographers, picture libraries offer a sound marketing knowledge and identify the outlets which are most suitable for the kind of subjects they photograph. As I mentioned in the previous chapter there is a huge demand for stock photographs and these images have to be sourced from somewhere. Picture libraries offer their potential clients not one but many views of a particular scene or building. They have to keep their libraries up to date and comprehensive, so as long as the photographer keeps them supplied with useable images then they could become a steady source of income. For many professional photographers stock architectural photography can ride on the back of other commissioned work but make sure you do not duplicate your clients' work for the picture library. Your client may not be too pleased if they see the photographs they paid you to take appearing in one of their competitor's publications a few months later.

The emphasis must be on quality and not quantity as it is one thing to get your images into a picture library, but quite another to make them stand out from those around them.

There are now architectural photographic libraries specifically created by architectural photographers banding together to market their own work collectively. A typical picture library called View was founded by Dennis Gilbert, Peter Cook and Chris Gascoigne in 1997 and now has numerous photographers on its books. They started the library because they needed to control and manage their own images and now collaborate with Alamy and a German library in order to market, their sales both in the UK and overseas. Alamy is especially useful for them as it gives their work good exposure in the American market but most libraries are now marketed worldwide via the internet and email.

If you do supply images to a picture library it is important to understand the contract and how you are able to use your images. Although stock libraries are very competitive, the usual commission fee is 50 per cent and the images remain the property of the photographer. It is useful to have adequate insurance covering fees, loss or damage of any material by the library or their clients. The safest approach to distributing images is to supply them digitally – if necessary by scanning – and sending on a CD or DVD or over an ISDN lines.

Advertizing agencies

Advertizing agencies specializing in producing property sales or corporate leasing brochures commission architectural photography for their clients to illustrate literature and sales leaflets on factories, office developments, apartments and commercial buildings, which are either for sale

or rent. These agencies usually prefer to use photographers who concentrate mainly on architectural commissions as they are used to working under pressure on site and handling tight deadlines without too much supervision. Property agencies such as these rely on on producing the photography quickly, as they tend to lose out if their client sells or lets the property before the agency has had time to complete the sales literature or website.

Builders and architects

Builders and construction firms commission photography on completion of the project and use the images for publicity, corporate brochures, end-of-year reports, accounts and websites or simply as archives for the company records. Progress photography is also sometimes required and usually an ongoing requirement in most building and construction projects providing the contractor with a set of images showing the activities and progress of the work from the start to its completion, the images become part of a permanent record of the projects progress. The photographer is usually given a set of fixed points around the site showing the angles and elevations required and a timetable, at weekly or monthly intervals for the duration of the construction.

Architects themselves require photographs, mainly for portfolios, documents and websites illustrating their designs and style of work. These are used for promotion purposes and pitching for new commissions. Most architects use computer-aided-design technology, showing 3D modelling of their designs, owing to the fact that architectural modelling is becoming so expensive. Computer-aided-design is partly dependent on photography and this avenue can be quite lucrative for photographers. It is basically photo montaging as the images are used to create panoramic photographs to show how a new building will look in its proposed location, and how it fits into the surrounding environment.

Other clients

There are many other potential clients for architectural photography. Government departments and local authorities use it to promote the ongoing regeneration of their buildings such as schools, hospitals, offices and housing schemes, as well as any new projects. These shoots often take the form of 'before and after' views of architectural projects involving public finances, to illustrate the changes made to existing buildings and the architectural impact on the local environment.

Some architectural photographers concentrate solely on photographing archaeological sites, ancient monuments and castles for government agencies and various heritage bodies. This sort of work is often very methodical, usually involving a lot of aerial and painstaking catalogue photography, but it can be fascinating watching ancient history unfold in front of your camera, either on location in a muddy field, near an castle or in the studio photographing ancient artefacts. There is also plenty of scope for more creative shots for illustrating brochures and other literature or even websites.

▲ This image of Southsea Pier, UK, burning is interesting to a number of different clients in a number of different ways; it has value as a news image and as a record of historical interest.

Hassleblad, exposure not recorded, ISO 64

Working with clients

The opportunities for architectural photography are many and varied but irrespective of the final application of the images it is very important the photographer strives to achieve the best possible quality regardless of their intended use, as this is what leads to further commissions.

Most clients have a good idea of what they require from a photographer even before they commission anyone. If an advertizing agency or design studio is involved in the planning stage of any printed, displayed or published material, then the client will have usually discussed the photography beforehand and artwork is supplied to the photographer showing how the images are going to be used. This can be helpful or very restrictive, but either way it will determine the creative expression of the photographer. Once the requirements for the assignment have been agreed, it is a good idea to determine if there is any flexibility before work commences.

▲ ▼ If the final shot is to be used in conjunction with text then make sure that you leave enough space for it. Although it can be tempting to fill the frame with every shot, leaving clean spaces will help the final design to look cleaner and less crowded.

The new place
for rising
companies

Commercially the only place for your business and employees

Bristol is the largest city in the South West and one of the fastest growing in the UK.

This makes it the perfect environment for employers and employees alike.

Its highly skilled and flexible workforce is an asset to any business moving into the area, as has already been found by companies such as Lloyds TSB, RAC and Orange.

Likewise, its two nationally recognised universities, plus several well-respected colleges of further and higher education, provide talent for businesses that prefer to create their own future.

For a virtual tour of South Plaza please visit www.southplaza.co.uk

PATENT GLAZING
SYSTEMS FROM
TECTONIC

Understanding how your picture is going to combine with text is a key part of visualizing the shot. Here the long vertical lines are ideally suited to the page format and match the layout of the text to the right.

Using a large-format camera makes it a lot easier to translate the detailed layouts accurately, which means the typography can be organized beforehand. Usually the designers provide an outline on a piece of tracing paper or acetate film, which is sized up in proportion and fits over the viewfinder glass to show how they want the images to match up with the rest of the designs on the page.

Photographers are usually commissioned either directly by the clients or sub-contracted by a third party, such as an advertizing agency or a commercial development company. Requirements are planned in advance so there are no misunderstandings and after the layout of pictures have been agreed and then the photographer should have a clear idea how the images are going to be dropped into the artwork. You should always obtain a copy of the brief in writing so you can discuss any aspects of the proposed shoot that should receive special treatment, how much space to leave on the covers for text.

It is important you understand exactly what pictures your client requires and if necessary ask for a prepared a visual outline of the layout, known as a shooting list. It is rare you will not be given an itemized written schedule and a copy of any artwork as it saves a lot of problems at a later stage over the size, shape and eventual cropping of your finished work.

There are many occasions when the pictures are required first and the layouts designed around them. The copywriter or designer uses your photographs as their visual guide but more often than not the photographs are dropped into existing

artwork. The amount of detail that is in the initial artwork will depend on the extent that the photographer is expected to follow and interpret them, as these layouts give a visual spacing guide to the composition.

Publicity material for some building developments is often needed well before the project has been completed so the client has some promotional material to hand out on its opening day or as a link to the new website. Sometimes the only photographs which can be used to illustrate an unfinished building are lifestyle images giving an impression or feel to the project making it desirable in the eyes of the potential buyer. These images give a visual style to the publication mirroring the design concept of an otherwise unfinished subject by relying on artwork or a storyboard supplied by the designer.

There are photographers who specialize in certain types of architectural photography, such as black & white, panoramas or interiors, rather than exteriors. However, the majority of architectural photographers are able to handle the photography required for most assignments without too many problems.

▶ **A walking brief from your client during a tour of the site is incredibly useful to point out features to include during the course of your shoot.**

The client should have confidence in the photographer they have commissioned to complete the brief required. After all, their reputations and the reputation of their practice are being illustrated by your photography. Your work is the shop window for their designs.

Whenever possible it is useful for your client to accompany you on site, either before any photographs are taken or during the assignment, as you'll find. Architects and designers have firm ideas on what they want photographed and which angles they want it photographed. Usually, once on site your client will give what is called 'a walking brief' and, during a tour of the site, point out relevant construction details on the building, which you as the photographer might have otherwise missed, including specific features to include during your shoot.

Every photographer has an individual style and how they see the subject and style and interpretation of the subject is the reason why they have been commissioned for certain projects and not others. Reputations are built on individual styles and certain photographers are commissioned to shoot a project their way because it suits the client. It can be very frustrating to be pigeonholed as an excellent interior photographer only to find some one else has been commissioned to undertake the exteriors on the same site. It has happened to me twice in my career but you have to bite the bullet and carry on with your part of the assignment.

Follow the brief you have already discussed with your client and don't be afraid to include some different images if you think they will add to the quality of the final project, but be careful if a budget has already been agreed.

Finances have to be discussed so that everyone involved is comfortable and understands what is required, but try and ascertain if there is some degree of flexibility in the budget for any extra time spent on the project waiting for cars to moved or the sun to come out and what contingencies, if any, are made for the weather or unknown elements which always seem to crop up at the last minute, this is discussed in greater detail in the previous chapter.

Any additional expenses, such as charges for preliminary visits to the site or hiring of assistants also should be discussed in advance to avoid any problems and embarrassment when submitting your invoice at a later date. If there is a fixed budget for the assignment and this restricts the number of photographs to be taken then it is advisable to work out, with the client, how many exteriors and interiors can be included within the time and costs allocated. Again, there is more on the subject of how much to charge in the previous chapter.

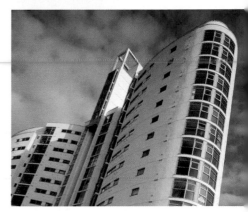

▲ ▶ On most assignments the photographer would be expected to have some photographic input as well some creative ideas. Show your client where you think some angles are better than others or the interesting pictures you could achieve if you tilted your camera away from the norm, resulting in a stunning image in comparison to what he originally envisaged. Watch the light changing as it moves across the building and notice how it affects the mood of the interior or adds strong shadows for a three-dimensional effect. Explain to the architect how different focal length lenses alter the perspective of the image in the viewfinder, creating an alternative feel to the subject.

📷 Sinar X, exposure not recorded, ISO 100

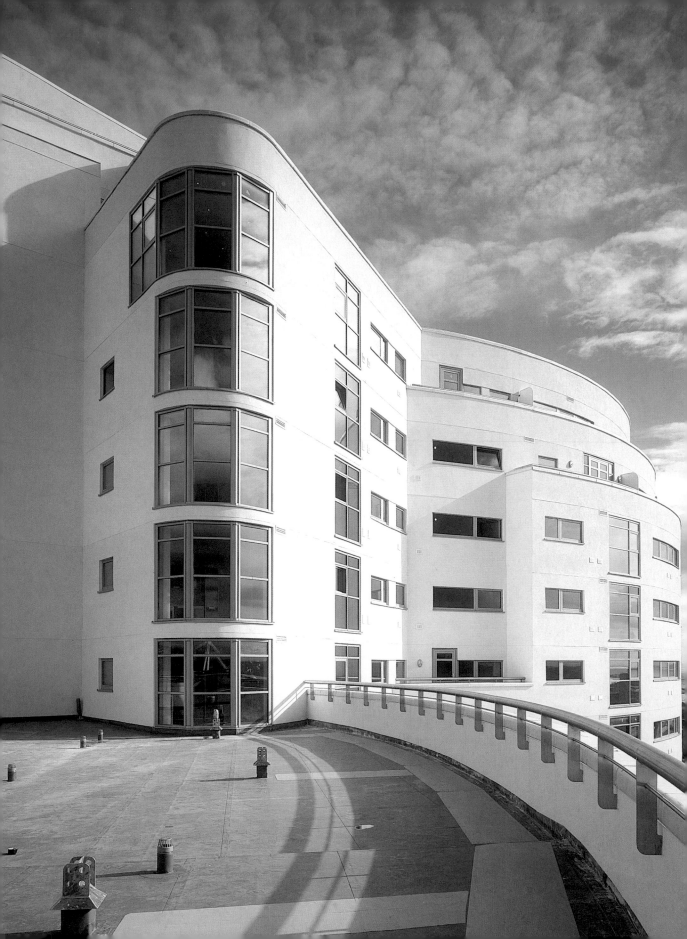

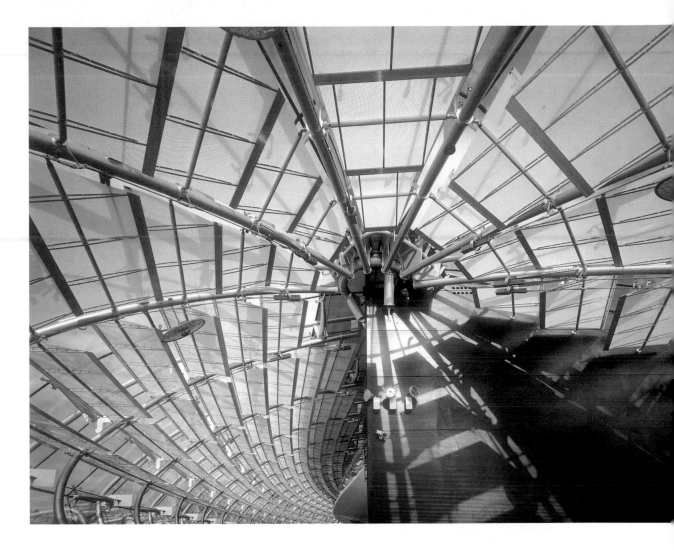

How many photographs can be shot in a day? This is difficult to quantify, as it depends on how methodical the photographer, and how complex the shoot, how many interior photographs are required and whether lights have to used and how much preparation is involved before a single image is exposed.

When the client knows exactly what is required then the photographer should receive a brief to work to, with the precise angles and elevations drawn out. The most common artwork supplied to an architectural photographer is usually a mock up of the final brochure, which is used as a guide, and although there is some input from the photographer, such as off-the-cuff shots of details or the changing light on the subject, you are usually expected to follow the design as closely as possible.

Sometimes all the photographer receives from the customer is a map showing the location and the address with a contact phone number. These are the briefs I prefer, as they show that

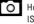 **The photographer–client relationship is based on trust and mutual respect, so your contribution is appreciated, after all a lot of time, effort and money have gone into the project and the client only wants it to look as good as you can possibly make it with your photographer's eye.**

Horseman LX, exposure not recorded, ISO 100

the client has confidence in your ability to achieve the desired results. Usually after you have the right quality of work on previous assignments.

During any brief it is important to find out as much information about the site you have been commissioned to photograph and sort out the logistics of the shoot. Don't forget to think about the basics such as whether there is room to park. Your vehicle containing cameras and lighting equipment needs to be easily accessible during the assignment just in case more equipment is needed. I always take a spare camera, film and more supplementary lighting than I need as a back up should the need arise, and keep it all locked away in an anonymous van as near to what I'm photographing as possible.

In these situations the security people, site foreman and receptionist can offer advice and help if you are polite and courteous. They are the people who sort out many of the problems you are likely to encounter on building sites, empty offices and industrial sites and finding somewhere for you to safely park, replacing broken fittings such as light bulbs and asking other contractors to give you some time and space during their busy schedules.

I was very lucky to receive a lot of help from two German security men during a difficult assignment in Berlin. I had four days to complete the photographs, both interiors and exteriors but unfortunately it rained every day I was there, so the only way I could complete the exteriors was to photograph the building at dusk. It was during the summer so it did not become dark until very late and everyone had gone home. When I set my camera up I noticed that some of the recessed lights in the pavement were not working and some of the lights in the retail outlets were turned off. After I had explained my problems to the security chief on site he immediately allocated two of his security staff to sort them out. They were only too pleased to help, mainly because during my time on their site I had asked for their co-operation, spent time drinking coffee with them and given them some of the instant-print photographs of a few of the images I exposed. They seemed to appreciate the fact I enjoyed their company, as a result they could not have been more helpful; but more on how to handle assignments in the next chapter.

Architects usually like to see people featured in some of the photographs to give scale and life to otherwise empty buildings. It makes sense to illustrate the building's function with the occupants actively using it and most people are quite happy, after being asked for their permission, appearing in photographs; some are even flattered at being asked in the first place. Although most people do not mind being photographed some will object and you have to respect their wishes. Posing members of staff or the general public and at the same time asking them to relax in front of the camera without feeling self-conscious and awkward can be challenging for most photographers. In such circumstances try and keep people in the middle or far distance and

▶ It is important to bear all of your client's requirements in mind for every photograph. This shot emphasizes the softer natural shape of the greenery in the foreground while including the scale of the interior. This highlights that this retail centre is a pleasant place to spend time.

🄾 Sinar X, exposure not recorded, ISO 100

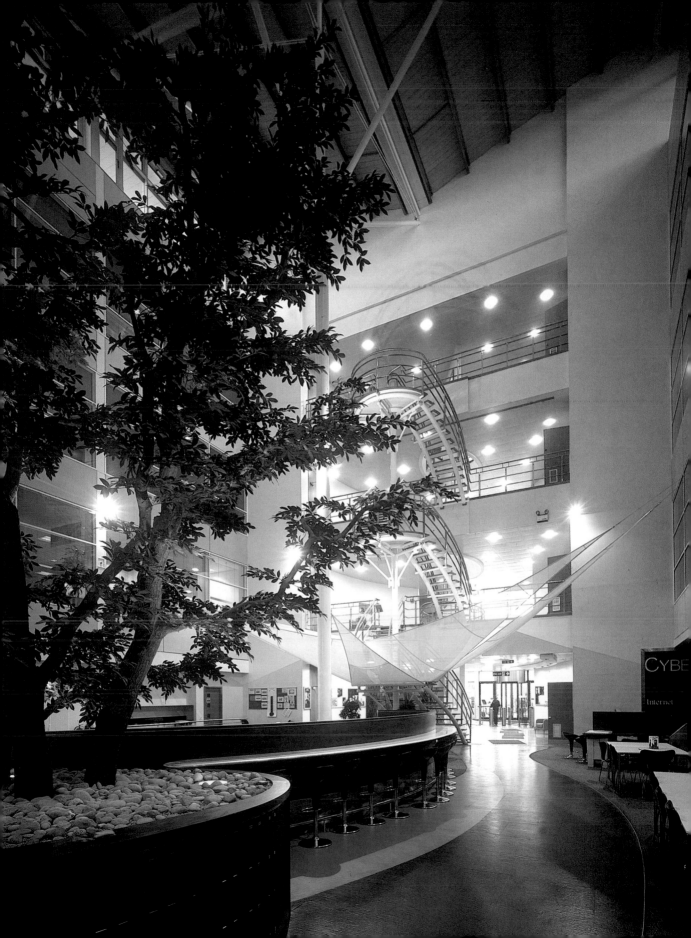

then they will not only give scale but be far enough away not to obscure any architectural features in the photograph and to cover up any unnatural expressions.

It may be necessary, even just courteous, to have a model release form available to be signed by members of the public appearing in any photograph you take on location. It is essential if the pictures are going to be used in any advertizing material, website or publicity by your client. This is especially true if you are shooting in hotels, restaurants, pubs, sports centres and retail outlets but often not essential in open public spaces if you and your camera are not on private property.

People add life to photographs, but too many people can dominate a photograph and detract from the main objective, which can be counterproductive, as some building features such as signage and staircases could be obscured by the mass of bodies. This not usually true in open public spaces, auditoriums and shopping malls but some people, once they have spotted the camera can become self-conscious and try and avoid walking in front of the lens, once one person does this many others will follow negating the very reason why you are including them.

The opposite reaction can also occur where groups of friends tend to wave their arms, pull faces or loiter nearby; in the hope they will have their photograph taken. It usually doesn't take them too long to usher the bolder member of the group to ask if you'll take their photograph. To overcome this pretend to press the shutter-release button and hope they go away; it is strange how often they accept the fact that you've taken their picture.

Case notes **21**

This was one of a series of pictures illustrating an outlet designer village near Bridgend in Wales, UK. I used the lines of the covered walkway to lead the viewer's eye into the picture and to frame the canopy on the right-hand side. The exposure had to be carefully measured in order to show detail in the canopy highlights and detail in the shadow area s underneath the covered walkway.

I tend to use a shutter speed of 1/30sec for most of my exposures, as the this is slow enough to allow a narrow enough aperture to give me a good depth of field by not too slow that people become blurred. In this image I have managed to keep the figures to the middle and far distance, which has prevented them from dominating the scene. It also helps to provide a good sense of scale, while showing the buildings as they are being used.

Gauging how to include people in your images is one of the trickier aspects of architectural photography, but after a while you will gain a strong feeling for when they add to and when they detract from a scene. Remember to focus on the main subject of the shot, do additional figures complement this or just obscure it?

📷 Sinar X, 1/30sec at f/16, ISO 64

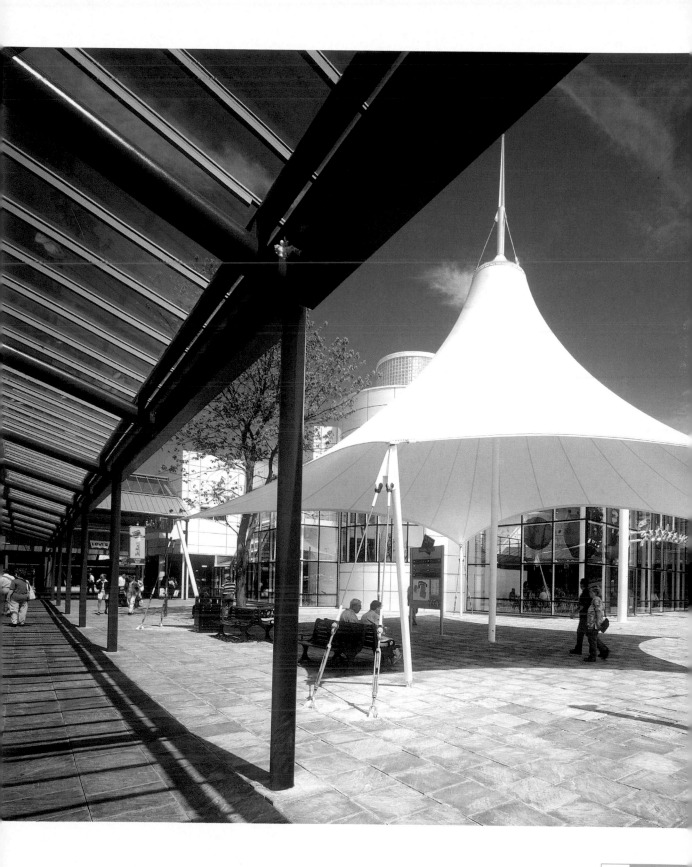

On assignment

Wherever you are shooting, and whatever the subject is there are certain challenges that will only arise when you are actually on assignment. It is difficult to predict these issues, but while you will always be surprised by something unexpected, a lot of problems are recurrent. If you have thought about these beforehand and are well prepared to meet them then you will be better placed to overcome them and get on with what you are interested in, taking great photographs of architecture. Although the best way of learning is through your own experience it can be tricky when you are getting started, so here are some useful pointers I've picked up along the way.

▲ Whether you are shooting images like this shot of Bath Abbey, UK, for your own pleasure or whether you are on assignment with a client, you should take the time to think about the task before you start out. That way you will be prepared for everything that is thrown at you.

📷 Toyo G, 4secs at f/16, ISO 64

One of the first problems a photographer has to overcome, after accepting the brief, is sorting out any logistical problems such as parking and finding a secure place to store your equipment. This is particularly an issue in built-up areas, city centres, busy industrial estates, residential complexes and construction sites. If your vehicle is carrying expensive camera and lighting equipment it is advisable to try and arrange a safe and convenient area to leave your vehicle so you can readily return to drop off exposed film or pick up any lights or camera accessories. Although it is only possible to use one camera on the assignment it is wise to carry a spare one just in case something goes wrong with the one you are using.

Check your insurance cover, as in certain circumstances you may find your equipment is not covered if left unattended in your vehicle. This is always a risk, especially if you have to leave your equipment while trying to find your contact on site, or parking in a city-centre car park a long way from where you intend taking your photographs.

Pre-planning

Pre-planning is essential and if possible a reconnaissance of the site could prove very useful. Sometimes photography is required during construction or just before the building is about to be handed over from the builders to their client and the site is very busy with workers, who seem to be going out of their way to make your life as difficult as possible by turning up in every shot just as you're going to take it. This is where patience becomes a virtue because it is worth remembering that contractors working on the site also have deadlines to meet, especially when the project is coming to fruition and penalty charges for late completion of the building are looming. The last thing they need is a photographer becoming awkward and insisting they hurry up and leave the premises so you can take some

photographs. Usually if the photographer is a 'prima donna' the other contractors on site go out of their way to make life more onerous for them. In these circumstances you just have to be patient, try to work round any obstacles and avoid any sort of confrontation while on site. If you are reasonable most contractors are helpful and let you take the pictures you need.

Obtaining a copy of the site plan showing the layout of the building prior to the day of photography is very useful, as this should show the direction of sunlight, the time of day exterior elevations are best photographed and help with choosing the camera view points for photography. A map showing the location of the site is also essential and it should have a grid reference and a compass reference in relation to the external pictures you have been asked to shoot.

Health and safety is crucial and the photographer should be aware of the rules and regulations concerning such a site. A hard hat, Day-Glo safety over jacket and safety shoes should be considered standard equipment and carried in your vehicle all the time, as the majority of sites will refuse you entry without them. Of course you should check before arriving on site whether you require any other equipment.

Most of the time the photographer is commissioned to photograph the building when it is empty or immediately before the new tenants are about to take possession. However health-and-safety regulations often insist you are inducted into the safety rules even before you are allowed on site and you should carry an identification badge at all times. Some countries such as the UK also require that flexible barriers and small A-frame signs displaying a 'man at work' logo enclose your camera when it is mounted on its tripod to avoid people tripping over it. All these measures cover the site owners against insurance claims if members of their staff are injured whilst you are photographing on their premises. As a professional photographer you

should have insurance covering you for working in public spaces but these extra precautions are to cover them for allowing you onto their site in the first place.

Sometimes exteriors of the building are required and the landscaping has not had time to mature or the area is strewn with discarded builders' rubble and your client has given you a very tight deadline. Usually some sort of compromise is arranged, even if it means a second visit to the site after the mess has been cleared or digital manipulation on a computer, where green grass, or water features can be added and any remaining building material left on the site, erased. These are techniques that you can use for any assignment whether it is paid or simply for enjoyment.

Photography is often commissioned to fit into a short window of time between the building's completion and it being handed over to the builder's client. This is when the building still looks new, without any blemishes, and the construction materials used to build it have not had time to become discoloured either by the weather or through use by the new occupants.

On any assignment it is a good idea to work out your shooting schedule and spend some time analyzing the task ahead. If there is a mixture of exterior and interior photographs try and decide which to do first. The angle of the sun will dictate the timing of some of your shots, as during early morning or late afternoon the sun will be low on the horizon and cast long

Case notes **22**

The client requested a daylight photograph of this new atrium but I realized he had not seen the building at night, when all the lights were on. During the day, while I was taking the photographs suggested in my brief from the design agency, I watched the lighting engineers test the blue lights in the roof of the atrium and knew that if I waited until dusk I could achieve a better image than the one I had photographed earlier in the day.

I used a wideangle lens on my large-format camera and tilted it up towards the ceiling to add drama to the photograph. Guess which image the property agent used for their brochure.

📷 Sinar X, exposure not recorded, ISO 100

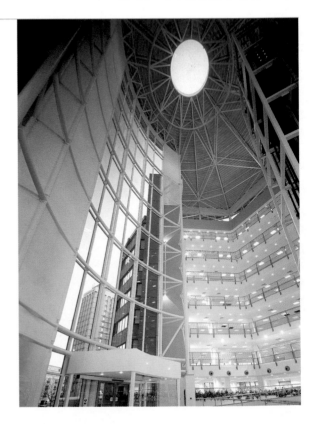

shadows. Remember that tall buildings can prove a problem by casting long shadows across the one you're shooting, or the sun may only shine on your subject at certain times of the day, so make sure your schedule will allow you not just to fit all of the required shots, but also allow you to shoot them at the correct time of day.

The weather will have an important part to play in your photography and subsequent timings. The local television station is usually accurate enough for the detailed weather forecast but a very detailed forecast can be seen on satellite images from the internet showing the direction of the winds and formations of the clouds. To achieve more visually interesting pictures, adverse weather conditions such as storm clouds and rainbows can add that extra dimension, but they rely on a lot of luck and patience. Sometimes, even the wet pavements on rainy days can be used to achieve interesting pictures, especially at night where the reflections of the lights from the buildings show in the puddles.

Other considerations

There are times, out of the usual working hours, where it is more convenient for your client for you to photograph some office interiors, factories and leisure facilities, thus avoiding any disruption or production costs. Weekends, the early hours of the morning or late at night can be the preferred out of hours times. Usually when the staff have finished for the day and left the building allowing photography to take place without too much disruption. I prefer these quiet times as I can relax, concentrating on the photography without worrying about people tripping over any lights or getting in the way of the camera. Health-and-safety issues are becoming very important in architectural photography and any way to avoid causing problems with staff is worth the inconvenience of unsocial hours.

I regularly work for a property development agency who commission me to work at weekends or after hours during the summer when the days are longer, because there are some occasions when they would rather the occupying tenants were oblivious to the fact that the building they are presently occupying is about to be sold by their landlords. It is surprising how many office blocks are bought and sold without the occupiers and tenants ever knowing who their new owners are, until the rental is due and a new landlord's name appears on their invoice. In the world of corporate business such acquisitions happen all the time and there are property agencies, one of whom I sometimes work for, specializing in such work. The converse has also happened where I've been photographing occupied offices and the staff have been told what is about to happen to their jobs or that the whole company is about to reallocate to a new building somewhere else, usually abroad so the company can cut costs and accordingly they have not appreciated my presence on site and have not been particularly helpful during the shoot. Their reaction is understandable but it is a good idea to avoid any confrontation,

▼ When taking this image I had just set the camera up and watched the CCTV camera pan round onto me and, within two minutes, two men in uniform approached and tried to stop me taking this photograph. They informed me that I could not photograph the building as the architects were claiming intellectual copyright, arguing that they claimed the moral right to any reproductions of their designs. I stated that I was on public land and was well within my rights to take the photograph. I stood my ground and eventually they backed off but it is going to become a big problem in the future.

📷 Horseman LKX, 1/30sec at f/16, ISO 64

◄ To achieve visually interesting pictures, adverse weather conditions such as storm clouds and rainbows can add that extra dimension but they rely on a lot of luck and patience. Sometimes, even the wet pavements on rainy days can be used to achieve interesting pictures, especially at night where the reflections of the lights from the buildings show in the puddles.

📷 Sinar X, exposure not recorded, ISO 100

usually by informing them you are just there to photograph the building and nothing else. On one job the facilities manager threw the office keys at me when I turned up stating, 'I'm out of a job tomorrow you sort your self out.'

Another problem that you will become aware of is that copyright is increasingly being claimed by architects on their building designs. While this won't affect commissioned photography, it may impinge upon shooting for stock, or even just amateur hobby photography. Architects and designers are claiming that they own the copyright for use of anything they design even if it is in the public domain and photographers face losing permission to photograph buildings without first receiving permission or paying a fee for the privilege. Worse still, the photographer's basic moral right to the images they produce could be under threat, with the emphasis slipping away from the use of the image to the ownership of it. The extent of the issue depends on the country in which you live, but it is an ever-increasing problem.

The bottom line with all architectural photography is that you should try to enjoy it. There are very few people that actually make a living from it, so for most people it will remain a hobby, albeit one that they can make a little money out of in addition to their day job. Understanding this should give you a good perspective with which to approach your subjects and I hope that this book has started you off on an enjoyable path.

Glossary

35mm film Photographic film that is 35mm wide and normally supplied in canisters with a useable frame size that is normally 24x36mm.

Aberration An imperfection in the image caused by the optics of a lens. All lenses suffer from aberrations, although they try to correct them in a number of ways.

Adobe Photoshop A widely used image-manipulation program.

Ambient light Light available from existing sources as opposed to light supplied by the photographer.

Angle of incidence The angle between the incident light falling on the subject and the reflected light entering the camera lens.

Angle of view The area of a scene that a lens takes in. A wideangle lens has a wide angle of view, while a telephoto lens has a narrow angle of view.

Aperture The opening in a camera lens through which light passes. The relative size of the aperture is denoted by f-numbers.

Aperture-priority mode An exposure mode in which the photographer chooses the aperture while the camera sets the shutter speed. If the aperture is changed, or the light level changes, the shutter speed is changed automatically.

Aperture ring A ring on the lens that controls the size of the aperture.

Aspect ratio The ratio of the width to the height of a frame.

Autoexposure (AE) The automatic measuring of light and setting an exposure.

Autofocus (AF) The camera's system of automatically focusing an image.

Ball-and-socket head A basic type of tripod head, which has a socket that rotates around a sphere and locks into place.

Bellows The folding portion in some cameras that connects the lens to the camera body. Also a camera accessory that, when inserted between the lens and camera body, extends the lens-to-film distance for close focusing.

Bounced flash Flash light that is bounced onto the subject from a ceiling, wall or reflector in order to soften shadows.

Bracketing The process of exposing a series of frames of the same subject or scene at a series of incrementally differing exposure settings.

Cast The abnormal colouring of an image.

CCD (charge-coupled device) A microchip made up of light-sensitive cells and used in digital cameras for recording images.

Centre-weighted metering A type of metering system that takes the majority of its reading from the central portion of the frame. It is suitable for portraits or scenes where subjects fill the centre of the frame.

Chromatic aberration The inability of a lens to bring the colours of the spectrum into focus at one point. This results in red–green fringing and is less of a problem with lenses that are designed with aspherical lens elements.

CMOS (complementary metal oxide semiconductor) A microchip made up of light-sensitive cells and used in digital cameras for recording images.

Cold colours Colours at the blue end of the visible spectrum, paradoxically they have high colour temperatures.

Colour-correction filters Filters that are used to correct colour casts.

Colour temperature Description of the colour of a light source by comparing it with the colour of light emitted by a theoretical perfect radiator at a particular temperature expressed in degrees Kelvin (K). 'Cool' colours such as blue have high colour temperatures while 'warm' colours have low colour temperatures.

Contrast The range between the highlight and shadow areas of a negative, print, slide or digital image. Also the difference in illumination between adjacent areas.

Contrast filters Filters used in black & white photography to enhance contrast between two colours that would normally record as a similar shade of grey. Colours matching the colour of the filter will lighten in the final image.

Cool-down filters Filters that add a cool cast to an image, or correct a warm cast.

Critical aperture The aperture setting at which a lens's performance is optimized, by balancing the imperfections caused by diffraction at narrow apertures and the quality lost to lens aberrations at wide apertures.

Cropped sensor A digital sensor that is smaller than a 35mm frame.

Daylight-balanced film Colour film for use with light sources with a colour temperature of approximately 5,400K – daylight.

Depth of field The amount of the image that is acceptably sharp, it extends one third in front of and two thirds behind the point of focus and is controlled by the aperture, focal length and camera-to-subject distance.

Depth-of-field preview Most SLRs offer the chance to preview the available depth of field by stopping down the aperture while the mirror remains in place.

Emulsion The light-sensitive coating of a film or photographic paper on which the latent image is formed.

Exposure compensation A level of adjustment given to autoexposure settings.

Filter A piece of coloured glass, or other transparent material, used over the lens or light source, or between the lens and camera to affect the colour or density of the scene.

Fisheye lens A super-wideangle lens which gives a 180° angle of view and often a circular image, although some can be rectangular.

Flare Non-image-forming light that scatters within the lens creating multi-coloured polygons or a loss in contrast. It can be reduced by multiple lens coatings, low-dispersion elements or the use of a lens hood.

Flash A form of artificial light generated by the full or partial discharge of a capacitor.

Focal length The distance, usually given in millimetres, from the optical centre point of a lens element to its focal point.

Focal plane A theoretical plane that intersects the optical axis at right angles running through the focal point. The plane in which the image is focused.

Focal point The point at which all rays of light from a given point on the subject re-form after being refracted by a lens.

Focusing The adjustment made to the distance between the lens and the film (and therefore the focal point) in order to bring the image into sharp focus.

Focusing screen A surface (traditionally ground glass now normally plastic) mounted on the focal plane of a large-format camera, on which the focus of the image can be checked.

f-numbers A fraction that indicates the actual diameter of the aperture: the 'f' represents the lens focal length.

Grain When the minute metallic silver deposit that forms the photographic image on film becomes visible in the image it is described as grain.

Graininess The granular appearance of a negative, print, or slide, which generally becomes more pronounced with faster film.

Grey card A grey card that reflects 18% of the light falling on it, representative of a middle-toned subject used for calculating exposure.

Incident light Light falling on a surface as opposed to that reflected from a service.

Incident-light meter An exposure meter that measures the light falling on the subject, rather than the light reflected by the subject.

Inverse square law The law that states that the variation in the intensity of light reaching a subject equals the inverse square of the change in distance. For example if a light source is moved 10x further away the amount of light reaching the surface will be 100x less.

ISO The international standard for representing film sensitivity. The emulsion speed (sensitivity) of the film as determined by the standards of the International Standards Organization. Digital cameras offer equivalent ratings.

Jpeg A compressed image file developed by the Joint Photographic Experts Group.

Kelvin (K) A scale used to measure colour temperature.

Large format Photography using a negative or transparency with a size of 5x4in or larger.

Medium format Photography using rollfilm (normally 120 or 220 rollfilm) that measures approx. 60mm wide. The frame size changes depending upon the camera.

Megapixel One million pixels.

Memory card Removable storage device for digital cameras.

Monorail camera A large-format camera in which the front and rear standards are mounted on a single rail in order to give it maximum movement.

Movements The movement of the standards of a large-format camera that alter focus, perspective and depth of field.

Multi-segment metering A metering system that uses a number of segments to calculate an exposure value.

Neutral-density (ND) filter A filter that reduces the brightness of an image without affecting the colour.

Neutral-density graduated filter A neutral filter that is graduated to allow different amounts of light to pass through the lens at different points. Used to even up bright and dark tones, especially to darken skies.

Noise The digital equivalent of graininess, caused by stray signals that occur more often at high ISO values or during long exposures.

On-demand gridlines A viewfinder display system showing a grid of intersecting lines.

Overexposure A condition in which too much light reaches the film or sensor, producing a dense negative or a light print or slide. Detail is lost in the highlights.

Pan-and-tilt A tripod head that allows movement in three axes.

Partial metering A metering mode that is only available on Canon cameras. It covers approximately 9% of the scene.

Pixels Abbreviation of picture elements. The individual units which make up a digital image.

Polarized light Light waves vibrating in one plane only as opposed to the multi-directional vibrations of normal rays. This occurs when light is reflected off certain surfaces.

Polarizing filter A filter that transmits light travelling in one plane while absorbing light travelling in other planes. It can eliminate reflections from subjects with a shiny surface except metals and is also used to saturate colours (often to make blue skies darker).

Prime lens A lens of a fixed focal length.

Programmed exposure An exposure mode that automatically sets both the aperture and the shutter speed for correct exposure.

Raw formats The proprietary formats of camera manufacturers that allow you to alter some image parameters on computer.

Reciprocity A change in one exposure setting can be compensated for by an equal but opposite change in the other. For example, the exposure settings of 1/125sec at f/8 for ISO 100 produce exactly the same exposure value as 1/60sec at f/11 for ISO 100.

Reciprocity law failure At shutter speeds slower than one second reciprocity begins to fail as film sensitivity reduces as exposure increases, the extent varies with different films.

Reflected-light meter A light meter measuring light reflected from, rather than light falling on, the surface of a subject.

Rollfilm 120- or 220-format film that is supplied on an open spool with paper backing.

Rule of thirds A compositional device that places the key elements of a scene along imagined lines that divide the frame into thirds, or at the intersections of these lines.

Screw-in filters Filters that screw onto the filter thread at the front of most modern lenses.

Sheet film Film for large-format cameras that is supplied in cut sheets rather than on rolls, and is mounted in film holders.

Shift The act of raising or lowering the lens or the camera back in order to correct perspective distortion.

Shutter-priority mode An exposure mode that lets you select the shutter speed while the camera sets the aperture. If you change the shutter speed, or the light level changes, the aperture adjusts automatically.

Shutter speed The length of time that the shutter is open. Measured in seconds and fractions of a second.

Silhouette An extreme example of a backlit image in which all surface detail in the subject is lost.

SLR (single lens reflex) A common type of camera that allows you to see through the camera's lens via the viewfinder.

Softbox An attachment that softens the light of a studio flash unit.

Soft focus An image that is not sharply focused. Often achieved by the used of uncorrected spherical aberration or filters.

Spot metering A metering mode that takes a light reading from a very small portion of the scene, often as little as 1°.

Standard The two moveable mountings of a large-format camera. The lens being attached to the front standard and the focusing screen or film back to the rear standard.

Standard lens A lens that provides the same approximate angle of view as the human eye.

Substitute reading A meter reading taken from an object of known reflectivity that is under the same lighting as the subject.

Swing The movement of the front or back standard pivoting around a vertical axis.

Telephoto lens A lens with a large focal length, with a narrow angle of view, giving the appearance of small or distant subjects appearing larger in the picture space.

Through-the-lens (TTL) metering A meter built into the camera that determines exposure by reading light that passes through the lens.

Tiff Tagged image file format: An uncompressed digital image file.

Tilt The movement of a lens or camera back pivoting around a horizontal axis.

Transparency A positive image with correct colour rendition on transparent film.

Tripod A three-legged camera support.

Tungsten-balanced film Colour film that gives a correct colour balance under tungsten light.

Underexposure A condition in which too little light reaches the film, producing a 'thin' negative, a dark slide, or a muddy-looking print or digital file. Detail is lost in the shadow areas of the exposure.

UV filter A filter that reduces UV interference in the image, thereby reducing haze.

View camera Another name for a large-format camera that has a ground-glass screen for focusing the image.

Vignetting The cropping or darkening of the corners of an image, caused by a a filter or lens hood encroaching on the frame or by the lens itself. Most lenses vignette to some extent, but this is only noticeable at wide apertures.

Warm-up filters Filters that add a warm cast to an image, or correct a cold cast.

White balance A function on a digital camera that allows the correct colour balance to be recorded for a specific lighting situation.

Wideangle lens A lens with a wider angle of view than the human eye.

Zoom lens A lens with a variable focal length that can be altered manually.

Useful information

Jim Lowe – Galleries of the author's work
www.jimlowe.co.uk

Photographers' Institute Press –
Photography books and magazines
www.pipress.com

Adobe – Image-manipulation software
ww.adobe.com

Canon – Cameras and accessories
www.canon.com

Epson – Printers and accessories
www.epson.com

Extensis – Image-handling software
www.extensis.com

Fujifilm – Cameras and film
www.fujifilm.com

Gitzo – Tripods
www.gitzo.com

Glorious Books – Portfolios and albums
www.gloriousbooks.net

Kodak – Cameras and film
www.kodak.com

Lastolite – Studio lighting and accessories
www.lastolite.com

Lowepro – Camera bags
www.lowepro.com

Manfrotto – Tripods
www.manfrotto.com

Metz – Flash units and accessories
www.metz.de/en

Nikon – Cameras and accessories
www.nikon.com

Novoflex – Photographic accessories
www.novoflex.com

Olympus – Cameras and accessories
www.olympus.com

Paterson – Distribution
www.patersonphotographic.com

Pentax – Cameras and accessories
www.pentaximaging.com

Sandisk – Memory cards
www.sandisk.com

Sigma – Lens and flash units
www.sigma-photo.com

Sto-fen – Flash accessories
www.stofen.com

Tamron – Lenses
www.tamron.com

Wimberley – Tripod heads
www.tripodhead.com

Index

Photographers' Institute Press
an imprint of The Guild of Master Craftsman Publications Ltd,
166 High Street, Lewes, East Sussex BN7 1XU
Tel: 01273 488005 Fax: 01273 402866
www.pipress.com

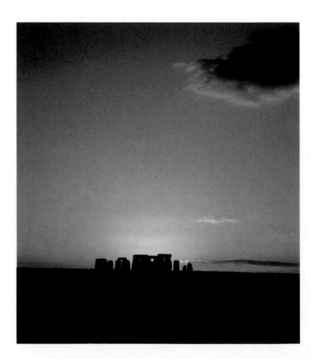